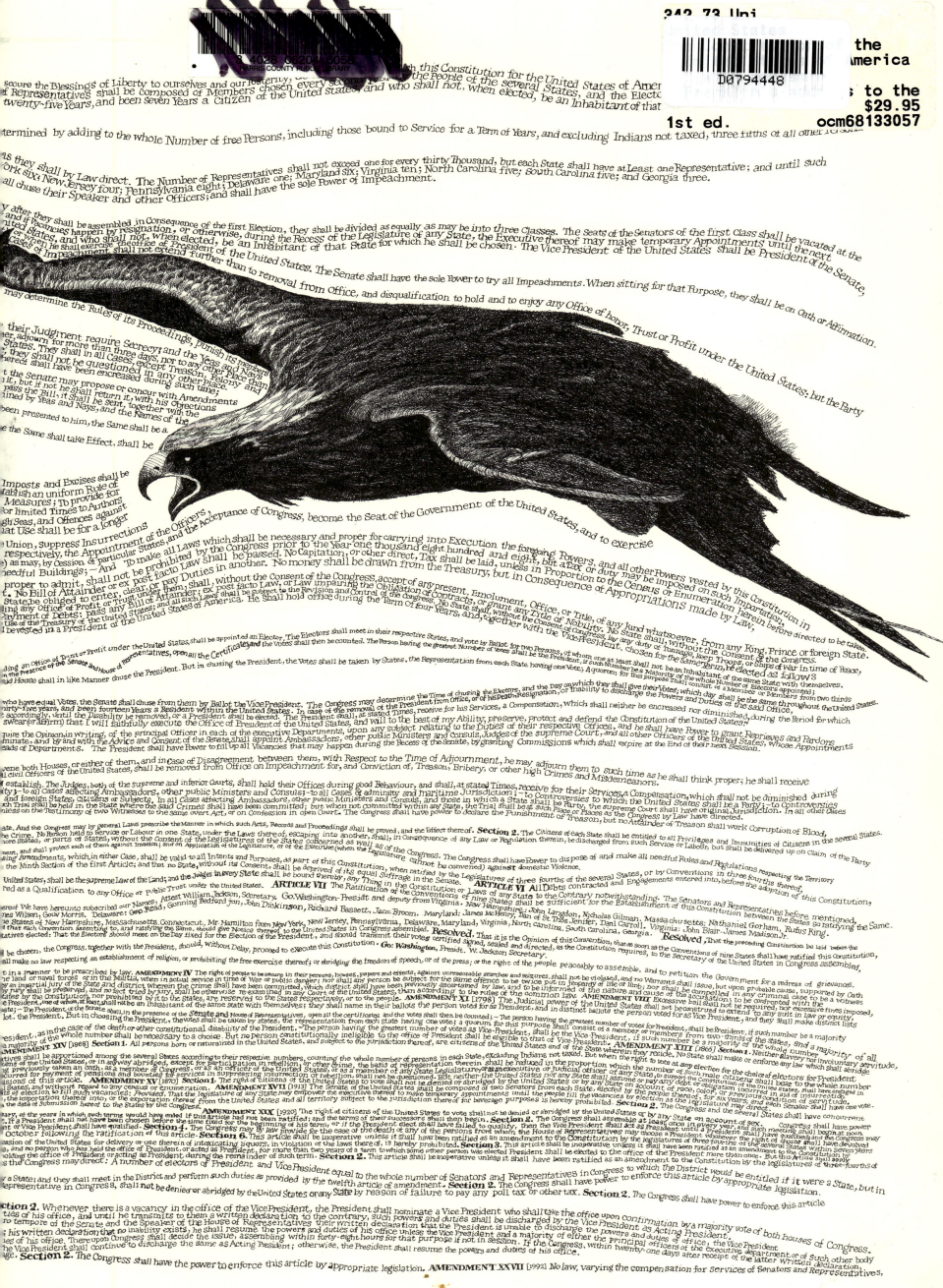

The Constitution of the United States of America

The Constitution
of the
United States of America

Inscribed and Illustrated by
Sam Fink

With Benjamin Franklin's Address to the Delegates
Upon the Signing of the Constitution

welcome
BOOKS

NEW YORK & SAN FRANCISCO

In memory
of my beloved wife, Adelle,
who encouraged me to dream.

And for Darwin "Dick" Bahm
who helped make
this dream come true.

ADDRESS TO THE DELEGATES

On September 17, 1787, a letter from Benjamin Franklin was read by James Wilson of Pennsylvania, after which the Constitution was signed and offered for ratification by the states.

I confess that I do not entirely approve of this Constitution at present, but Sir, I am not sure I shall never approve it: For having lived long, I have experienced many Instances of being oblig'd, by better Information or fuller Consideration, to change Opinions even on important Subjects, which I once thought right, but found to be otherwise. It is therefore that the older I grow the more apt I am to doubt my own Judgment and to pay more Respect to the Judgment of others. Most Men indeed as well as most Sects in Religion, think themselves in Possession of all Truth, and that wherever others differ from them it is so far Error. Steele, a Protestant, in a Dedication tells the Pope, that the only Difference between our two Churches in their opinions of the certainty of their Doctrine, is, the Roman Church is infallible, and the Church of England is never in the wrong. But tho' many private Persons think almost as highly of their own Infallibility, as of that of their Sect, few express it so naturally as a certain French lady, who in a little Dispute with her Sister, said, I don't know how it happens, Sister, but I meet with no body but myself that's *always* in the right. *Il n'y a que moi qui a toujours raison.*

In these Sentiments, Sir, I agree to this Constitution, with all its Faults, if they are such: because I think a General Government necessary for us, and there is no *Form* of Government but what may be a Blessing to the People if well administered; and I believe farther that this is likely to be well administered for a Course of Years, and can only end in Despotism as other Forms have done before it, when the People shall become so corrupted as to need Despotic Government, being incapable of any other. I doubt too whether any other Convention we can obtain, may be able to make a better Constitution: For when you assemble a Number of Men to have the Advantage of their joint Wisdom, you inevitably assemble with those Men, all their Prejudices, their Passions,

their Errors of Opinion, their local Interests, and their selfish Views. From such an Assembly can a perfect Production be expected? It therefore astonishes me, Sir, to find this System approaching so near to Perfection as it does; and I think it will astonish our Enemies, who are waiting with Confidence to hear that our Councils are confounded, like those of the Builders of Babel, and that our States are on the Point of Separation, only to meet hereafter for the Purpose of cutting one another's Throats. Thus I consent, Sir, to this Constitution because I expect no better, and because I am not sure that it is not the best. The Opinions I have had of its Errors, I sacrifice to the Public Good. I have never whisper'd a Syllable of them abroad. Within these Walls they were born, & here they shall die. If every one of us in returning to our Constituents were to report the Objections he has had to it, and endeavor to gain Partizans in support of them, we might prevent its being generally received, and thereby lose all the salutary Effects & great Advantages resulting naturally in our favor among foreign Nations, as well as among ourselves, from our real or apparent Unanimity. Much of the Strength and Efficiency of any, Government in procuring & securing Happiness to the People depends on Opinion, on the general Opinion of the Goodness of that Government as well as of the Wisdom & Integrity of its Governors. I hope therefore that for our own Sakes, as a Part of the People, and for the Sake of our Posterity, we shall act heartily & unanimously in recommending this Constitution, wherever our Influence may extend, and turn our future Thoughts and Endeavors to the Means of having it well administred.—

On the whole, Sir, I can not help expressing a Wish, that every Member of the Convention, who may still have Objections to it, would with me on this Occasion doubt a little of his own Infallibility, and to make *manifest* our *Unanimity*, put his Name to this Instrument.—

B Franklin

The Constitution of the United States of America

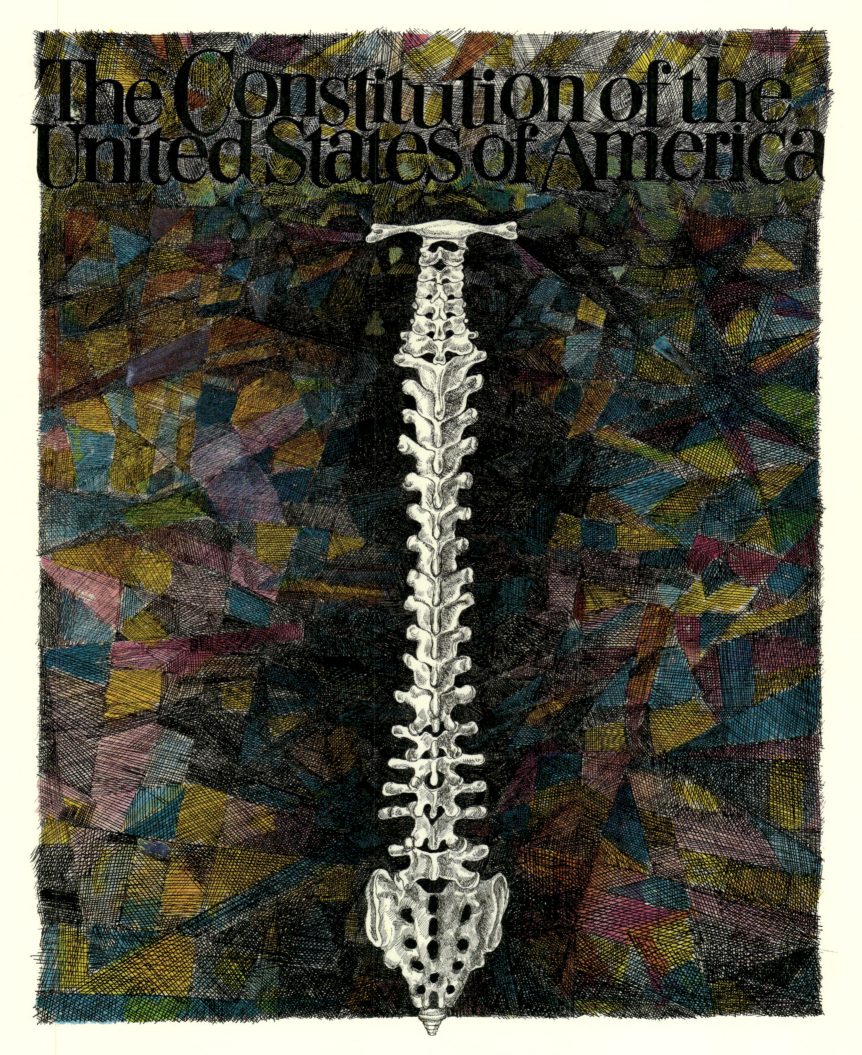

This is a Backbone.

Man cannot stand erect without one. Neither can a country.
The backbone of the United States of America is her Constitution.

There are features in his face totally different from what I ever observed in that of any other human being; the sockets of the eyes, for instance, are larger and the upper part of his nose broader. All his features are indicative of the strongest passions, yet his judgement and great command make him appear a man of a different cast in the eyes of the world. *GILBERT STUART*

Washington is the mightiest name on earth... long since mightiest in the cause of civil liberty; still mightiest in moral reformation. On that name an eulogy is expected. Let none attempt it. In solemn awe, pronounce the name, and in its naked deathless splendor leave it on shining. *ABRAHAM LINCOLN*

George Washington as a boy was ignorant of the commonest accomplishments of youth. He could not even lie. *MARK TWAIN*

A gentleman of one of the first fortunes on the continent, sacrificing his ease, and hazarding all in the cause of his country. *JOHN ADAMS*

He errs as other men do but He errs with dignity. *T. JEFFERSON*

G Washington — Presid

There has scarcely appeared a really great man whose character has been more greatly admired in his lifetime or less correctly understood by his admirers...his talents were adopted to lead without dazzling mankind, and to draw forth and employ the talents of others without being misled by them. *FISHER AMES*

His mind was great and powerful without being of the very first order; his penetration strong, though not so acute as that of Newton, Bacon or Locke, and as far as he saw no judgement was ever sounder. It was slow in operation being little aided by invention or imagination but sure in conclusion. *THOMAS JEFFERSON*

Gouverneur Morris

Gouverneur Morris of Pennsylvania. It is said he wrote the preamble and that he did it quickly. As a young man he drove around Philadelphia in a four wheel carriage drawn by a pair of spirited horses. One day as he climbed aboard the horses bolted. The coach overturned and landed on Morris. His leg was smashed beyond repair and had to be amputated. For the rest of his life he pegged around on a wooden leg. This disability never slowed him down.....nor diminished his zest for life.

The Preamble

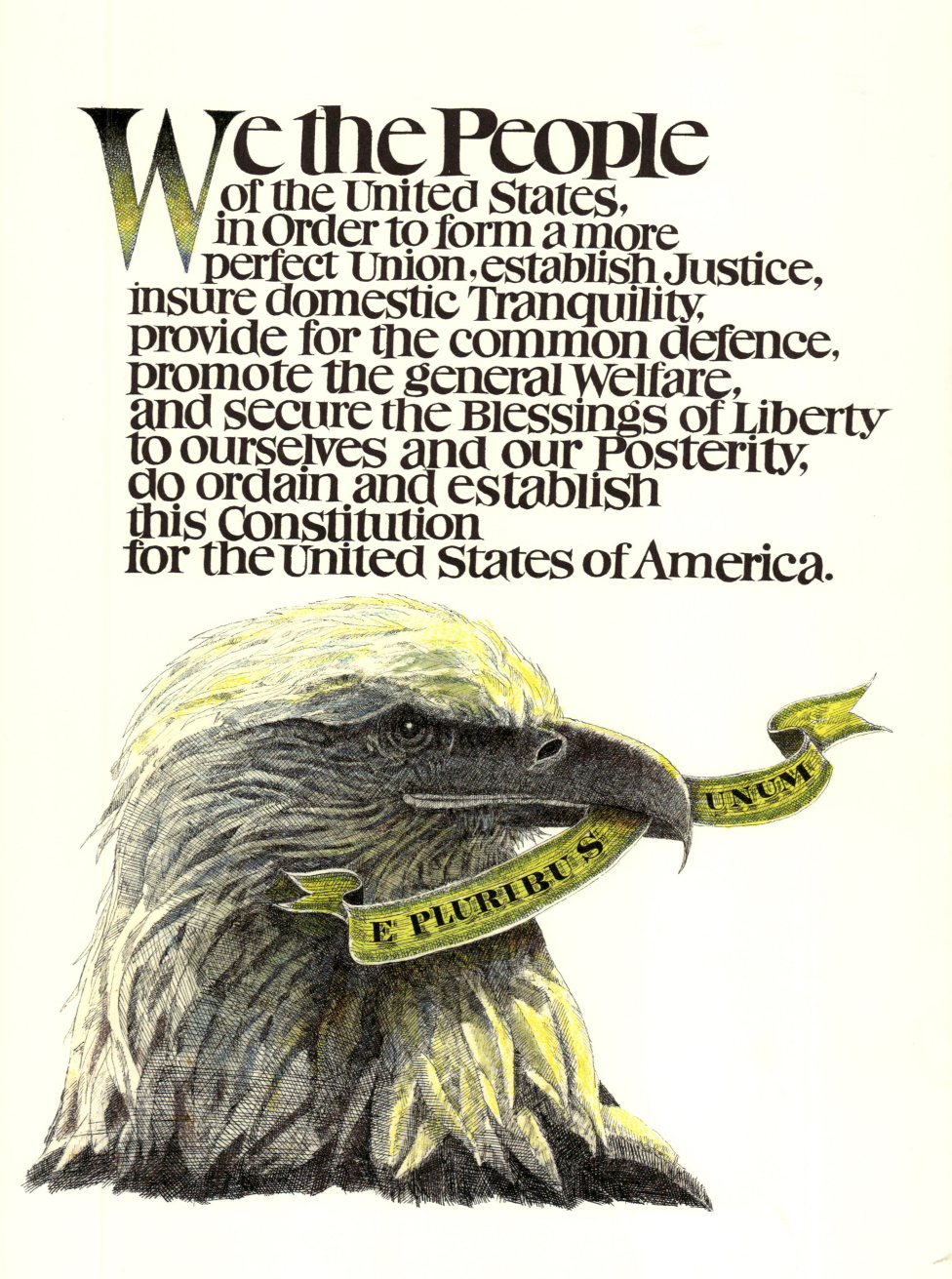

Article I
Section 1.
Section 2.

Article 1

Section 1. All legislative Powers herein granted shall be vested in a Congress of the United States, which shall consist of a Senate and House of Representatives.

Section 2. The House of Representatives shall be composed of Members chosen every second Year by the People of the several States, and the Electors in each State shall have the Qualifications requisite for Electors of the most numerous Branch of the State Legislature.

No Person shall be a Representative who shall not have attained to the Age of twenty-five Years, and been seven Years a Citizen of the United States, and who shall not, when elected, be an Inhabitant of that State in which he shall be chosen.

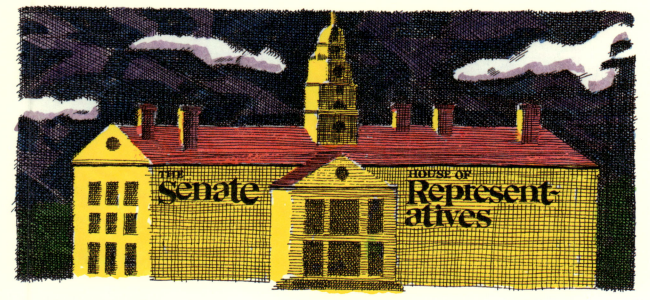

Article I
Section 2.
(continued)

epresentatives and direct Taxes shall be apportioned among the several States which may be included within this Union, according to their respective Numbers, which shall be determined by adding to the whole Number of free Persons, including those bound to Service for a Term of Years, and excluding Indians not taxed, three fifths of all other Persons. The actual Enumeration shall be made within three Years after the first Meeting of the Congress of the United States, and within every subsequent Term of ten Years, in such Manner as they shall by Law direct. The Number of Representatives shall not exceed one for every thirty Thousand, but each state shall have at least one Representative; and until such enumeration shall be made, the State of New Hampshire shall be entitled to chuse three; Massachusetts eight; Rhode Island and Providence Plantations one; Connecticut five; New York six; New Jersey four; Pennsylvania eight; Delaware one; Maryland six; Virginia ten; North Carolina five; South Carolina five; and Georgia three.

N.Y.

N.H.

Mass.

Conn. R.I.

Pennsylvania

N.J.

Maryland

DEL.

Virginia

North Carolina

South Carolina

Georgia

Atlantic Ocean

The Thirteen States :::::

When vacancies happen in the Representation from any State, the Executive Authority thereof shall issue

Writs of Election to fill such Vacancies.

The House of Representatives shall chuse their Speaker and other Officers; and shall have the sole **Power of Impeachment.**

Article I
Section 3.

Section 3. The Senate of the United States shall be composed of two Senators from each State, chosen by the Legislature thereof, for six Years; and each Senator shall have one Vote.

Immediately after they shall be assembled in Consequence of the first Election, they shall be divided as equally as may be into three Classes. The Seats of the Senators of the first Class shall be vacated at the Expiration of the second Year, of the second Class at the Expiration of the fourth Year, and of the third Class at the Expiration of the sixth Year, so that one third may be chosen every second Year; and if Vacancies happen by Resignation, or otherwise, during the Recess of the Legislature of any State, the Executive thereof may make temporary Appointments until the next Meeting of the Legislature, which shall then fill such Vacancies.

No Person shall be a Senator who shall not have attained to the Age of thirty Years, and been nine Years a Citizen of the United States, and who shall not, when elected, be an Inhabitant of that State for which he shall be chosen.

The Vice President of the United States shall be the President of the Senate, but shall have no Vote, unless they be equally divided.

Article I
Section 3.
(continued)
Section 4.

The Senate shall chuse their other Officers, and also a President pro tempore, in the absence of the Vice President, or when he shall exercise the Office of President of the United States.

The Senate shall have the sole Power to try all Impeachments. When sitting for that Purpose, they shall be on Oath or Affirmation.

When the President of the United States is tried, the Chief Justice shall preside: And no Person shall be convicted without the Concurrence of two thirds of the Members present.

Judgment in Cases of Impeachment shall not extend further than to removal from Office, and disqualification to hold and enjoy any Office of honor,

Trust or Profit under the United States: but the Party convicted shall nevertheless be liable and subject to Indictment, Trial, Judgment and Punishment, according to Law.

Section 4. The Times, Places and Manner of holding Elections for Senators and Representatives, shall be prescribed in each State by the Legislature thereof; but the Congress may at any time by Law make or alter such Regulations, except as to the Places of chusing Senators.

Article I
Section 4.
(continued)
Section 5.

The Congress shall assemble at least once in every Year, and such Meeting shall be the first Monday in December, unless they shall by Law appoint a different Day.

Section 5. Each House shall be the Judge of the Elections, Returns and Qualifications of its own Members, and a Majority of each shall constitute a Quorum to do Business; but a smaller Number may adjourn from day to day, and may be authorized to compel the Attendance of absent Members, in such Manner, and under such Penalties as each House may provide. Each House may determine the Rules of its Proceedings, punish its Members for disorderly Behavior, and, with the Concurrence of two thirds, expel a Member. Each House shall keep a Journal of its Proceedings, and from time to time publish the same, excepting such Parts as may in their Judgment require Secrecy; and the Yeas and Nays of the Members of either House on any question shall, at the Desire of one fifth of those Present, be entered on the Journal.

It says in Catherine Drinker Bowen's book, "Miracle at Philadelpia", there were sufficient numbers of doves of peace in the room where the Delegates met so each one had a dove perched on his shoulder as they wrote the Constitution.

Article I
Section 6.
Section 7.

Section 6. The Senators and Representatives shall receive a Compensation for their Services, to be ascertained by Law, and paid out of the Treasury of the United States. They shall in all Cases, except Treason, Felony and Breach of the Peace, be privileged from Arrest during their attendance at the Session of their respective Houses, and in going to and returning from the same; and for any Speech or Debate in either House, they shall not be questioned in any other Place.

No Senator or Representative shall, during the Time for which he was elected, be appointed to any civil Office under the Authority of the United States which shall have been created, or the Emoluments whereof shall have been encreased during such time; and no Person holding any Office under the United States, shall be a Member of either House during his Continuance in Office.

Section 7. All Bills for raising Revenue shall originate in the House of Representatives; but the Senate may propose to concur with Amendments as on other Bills.

Every Bill which shall have passed the House of Representatives and the Senate shall, before it become a Law, be presented to the President of the United States; If he approve he shall sign it, but if not he shall return it, with his Objections to that House in which it shall have originated, who shall enter the Objections at large on their Journal, and proceed to reconsider it. If after such Reconsideration two thirds of that House shall agree to pass the Bill, it shall be sent, together with the Objections, to the other House,

Yea

Yea

Nay

Article I
Section 7.
(continued)

Yea

by which it shall likewise be reconsidered, and if approved by two thirds of that House, it shall become a Law. But in all such Cases the Votes of both Houses shall be determined by Yeas and Nays, and the Names of the Persons voting for and against the Bill shall be entered on the Journal of each House respectively. If any Bill shall not be returned by the President within ten Days (Sundays excepted) after it shall have been presented to him, the Same shall be a Law, in like Manner as if he had signed it, unless the Congress by their Adjournment prevent its Return, in which Case it shall not be a Law.

Yea

Nay

Every Order, Resolution, or Vote to which Concurrence of the Senate and House of Representatives may be necessary (except on a Question of Adjournment) shall be presented to the President of the United States; and before the Same shall take Effect, shall be approved by him, or being disapproved by him shall be repassed by two thirds of the Senate and House of Representatives, according to the Rules and Limitations prescribed in the Case of a Bill.

Article I
Section 8.

Section 8. The Congress shall have Power To lay and collect Taxes, Duties, Imposts and excises, to pay the Debts and provide for the common Defence and general Welfare of the United States; but all Duties, Imposts and Excises shall be uniform throughout the United States;

To borrow money on the credit of the United States;

To regulate Commerce with foreign Nations, and among the several States, and with the Indian Tribes;

To provide for the Punishment of counterfeiting the Securities and current Coin of the United States;

To establish Post Offices and post Roads;

To promote the Progress of Science and useful Arts, by securing for limited Times to Authors and Inventors the exclusive Right to their respective Writings and Discoveries;

To estabish an uniform Rule of Naturalization, and uniform Laws on the subject of Bankruptcies throughout the United States;

To coin Money, regulate the Value thereof, and of foreign Coin, and fix the Standard of Weights and Measures;

To constitute Tribunals inferior to the Supreme Court;

To define and punish Piracies and Felonies committed on the high Seas, and Offences against the Law of Nations;

To declare War, grant letters of Marque and Reprisal, and make Rules concerning Captures on Land and Water;

Article I
Section 8.
(continued)

To raise and support Armies, but no Appropriation of Money to that Use shall be

for a longer Term than two Years;

To provide and maintain a Navy;

To make Rules for the Government and Regulation of the land and naval Forces;

To provide for calling forth the Militia to execute the Laws of the Union, suppress Insurrections and repel Invasions;

To provide for organizing, arming, and disciplining the Militia, and for governing such Part of them as may be employed in the Service of the United States, reserving to the States respectively, the Appointment

of the Officers, and the Authority of training the Militia according to the discipline prescribed by Congress;

To exercise exclusive Legislation in all Cases whatsoever,

Legislature of the State in which the Same shall be, for the Erection of Forts, Magazines, Arsenals, dock-Yards, and other needful Buildings;—And

To make all Laws which shall be necessary and proper for carrying

into Execution the foregoing Powers, and all other Powers vested by this Constitution in the Government of the United States, or in any Department or Officer thereof.

over such District (not exceeding ten Miles square) as may, by Cession of particular States, and the Acceptance of Congress, become the Seat of the Government of the United States, and to exercise like Authority over all Places purchased by the Consent of the

Article I
Section 9.

Section 9. The Migration or Importation of Such Persons as any of the States now existing shall think proper to admit, shall not be prohibited by the Congress prior to the year one thousand eight hundred and eight, but a tax or duty may be imposed on such Importation, not exceeding ten dollars for each Person.

The privilege of the Writ of Habeas Corpus shall not be suspended, unless when in Cases of Rebellion or Invasion the public Safety may require it.

No Bill of Attainder or ex post facto Law shall be passed.

No capitation, or other direct, Tax shall be laid, unless in Proportion to the Census or Enumeration herein before directed to be taken.

No Tax or Duty shall be laid on Articles exported from any State.

No Preference shall be given by any Regulation of Commerce or Revenue to the Ports of one State over those of another: nor shall Vessels bound to, or from, one State, be obliged to enter, clear, or pay Duties in another.

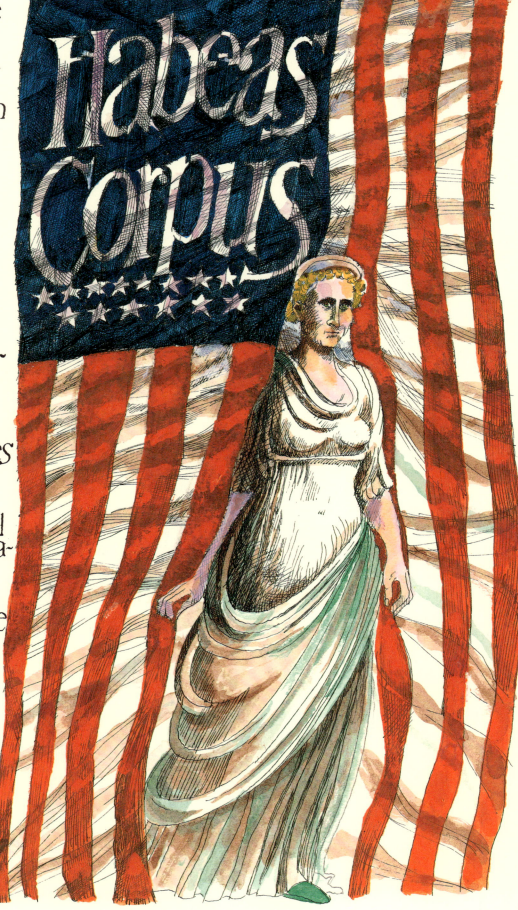

No money shall be drawn from the Treasury, but in Consequence of Appropriations made by Law; and a regular Statement and Account of the Receipts and Expenditures of all public Money shall be published from time to time.

Article I
Section 9.
(continued)
Section 10.

No Title of Nobility shall be granted by the United States: And no Person holding any Office of Profit or Trust under them, shall, without the Consent of the Congress, accept of any present, Emolument, Office, or Title, of any kind whatever, from any King, Prince or foreign State.

No State shall, without the Consent of the Congress, lay any Imposts or Duties on Imports or Exports, except what may be absolutely necessary for executing its inspection Laws: and the net Produce of all Duties and Imposts, laid by any State on Imports or Exports, shall be for the Use of the Treasury of the United States; and all such Laws shall be subject to the Revision and Controul of the Congress.

Section 10.

No State shall enter into any Treaty, Alliance, or Confederation; grant Letters of Marque and Reprisal; coin Money; emit Bills of Credit; make any Thing but gold and silver Coin a Tender in Payment of Debts; pass any Bill of Attainder, ex post facto Law, or Law impairing the Obligation of Contracts, or grant any Title of Nobility.

No State shall, without the Consent of the Congress, lay any duty of Tonnage, keep Troops, or Ships of War in time of Peace, enter into any Agreement or Compact with another State, or with a foreign Power, or engage in War, unless actually invaded, or in such imminent Danger as will not admit of delay.

Hugo La Fayette Black

*My friend, Charley Feldman, remembers what people say. He remembers exactly. Years ago he listened to a television interview with **Hugo La Fayette Black**, Associate Justice of the Supreme Court for 34 years.
When Black was asked a question on the Constitution, he whipped out a dog-eared little book from his pocket, a copy of the Constitution. "It's all in this little book. I carry it with me all the time," he said.

Article II
Section 1.

Article II

Section 1. The executive Power shall be vested in a President of the United States of America. He shall hold his Office during the Term of four Years, and, together with the Vice President, chosen for the same Term, be elected as follows

Each State shall appoint, in such Manner as the Legislature thereof may direct, a Number of Electors, equal to the whole Number of Senators and Representatives to which the State may be entitled in the Congress: but no Senator or Representative, or Person holding an Office of Trust or Profit under the United States, shall be appointed an Elector.

The Electors shall meet in their respective States, and vote by Ballot for two persons, of whom one at least shall not be an Inhabitant of the same State with themselves. And they shall make a List of all Persons voted for, and of the Number of Votes for each; which List they shall sign and certify, and transmit sealed to the Seat of the Government of the United States, directed to the President of the Senate. The President of the Senate shall, in the Presence of the Senate and House of Representatives, open all the Certificates, and the Votes shall then be counted.

Washington is the mightiest name on earth–long since mightiest in the cause of civil liberty; still mightiest in moral reformation. On that name an eulogy is expected. Let none attempt it.
In solemn awe pronounce the name, and in its naked deathless splendor leave it on shining.

Abraham Lincoln

Article II
Section 1.
(continued)

Federal Convention

like Manner chuse the President. But in chusing the President, the Votes shall be taken by States, the Representation from each State having one Vote; A quorum for this Purpose shall consist of a Member or Members from two thirds of the States, and a Majority of all the States shall be necessary to a Choice. In every Case, after the Choice of the President, the Person having the greatest Number of Votes of the Electors shall be the Vice President. But if there should remain two or more who have equal Votes, the Senate shall chuse from them by Ballot the Vice President.

The Congress may determine the Time of chusing the Electors, and the Day on which they shall give their Votes; which Day shall be the same throughout the United States.

The Person having the greatest Number of Votes shall be the President, if such Number be a Majority of the whole Number of Electors appointed; and if there be more than one who have such Majority, and have an equal Number of Votes, then the House of Representatives shall immediately chuse by Ballot one of them for President; and if no Person have a Majority, then from the five highest on the List the said House shall in

During the first week of July 1787, frustration and disappointment crept into the Convention. The weather in Philadelphia was punishing. Several pulled out and went home.
Luther Martin, New Jersey Delegate, a States' rights advocate, wrote: "We were on the verge of dissolution... scarce held together by the strength of an hair...."
In opposition to the National Government, Luther Martin never did sign the Constitution.

Article II
Section 1.
(continued)

No person except a natural born Citizen, or a Citizen of the United States, at the time of the Adoption of this Constitution, shall be eligible to the office of President; neither shall any Person be eligible to that Office who shall not have attained to the Age of thirty-five years, and been fourteen Years a Resident within the United States.

In case of the Removal of the President from Office, or of his Death, Resignation, or Inability to discharge the Powers and Duties of the said Office, the same shall devolve on the Vice President, and the Congress may by Law provide for the Case of Removal, Death, Resignation or Inability, both of the President and Vice President, declaring what Officer shall then act as President, and such Officer shall act accordingly, until the Disability be removed, or a President shall be elected.

The President shall, at stated Times, receive for his Services, a Compensation, which shall neither be encreased nor diminished during the Period for which he shall have been elected, and he shall not receive within that Period any other Emolument from the United States, or any of them.

Before he enter on the Execution of his Office, he shall take the following Oath or Affirmation:~ "I do solemnly swear (or affirm) that I will faithfully execute the Office of President of the United States, and I will to the best of my Ability, preserve, protect and defend the Constitution of the United States."

Article II
Section 2.

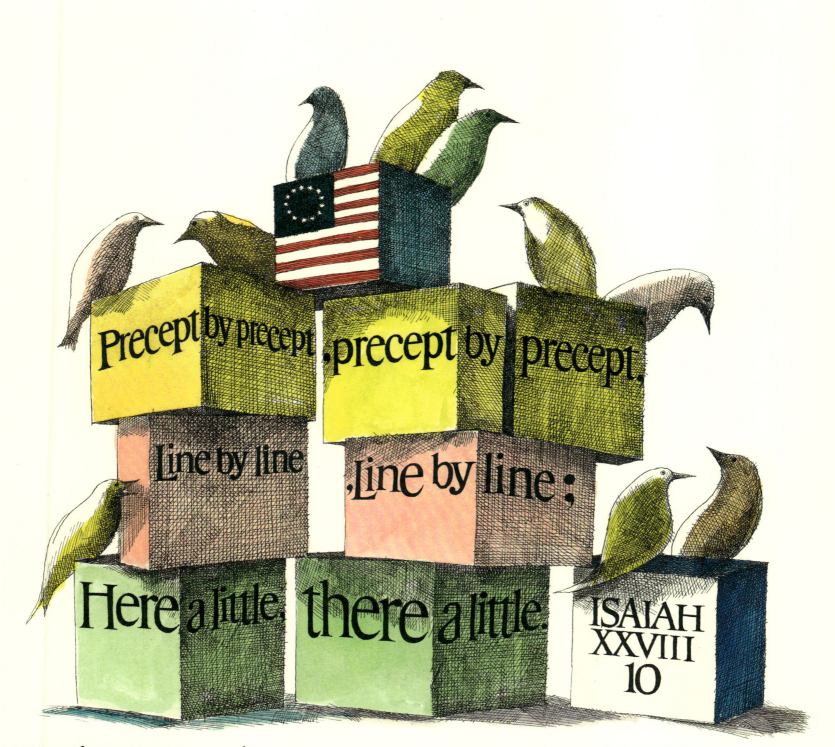

Precept by precept, precept by precept.

Line by line, Line by line:

Here a little, there a little.

ISAIAH XXVIII 10

Section 2. The President shall be Commander in Chief of the Army and Navy of the United States, and of the Militia of the several States, when called into the actual Service of the United States; he may require the Opinion, in writing, of the principal Officer in each of the executive Departments, upon any subject relating to the Duties of their respective Offices, and he shall have Power to grant Reprieves and Pardons for Offenses against the United States, except in Cases of Impeachment.

He shall have Power, by and with the Advice and Consent of the Senate, to make Treaties, provided two thirds of the Senators present concur; and he shall nominate, and by and with the Advice and Consent of the Senate, shall appoint Ambassadors, other public Ministers and Consuls, Judges of the supreme Court, and all other Officers of the United States, whose Appointments are not herein otherwise provided for, and which shall be established by Law; but the Congress may by Law vest the Appointment of such inferior Officers, as they think proper, in the President alone, in the Courts of Law, or in the Heads of Departments.

The President shall have Power to fill up all Vacancies that may happen during the Recess of the Senate, by granting Commissions which shall expire at End of their next Session.

Article II
Section 3.
Section 4.

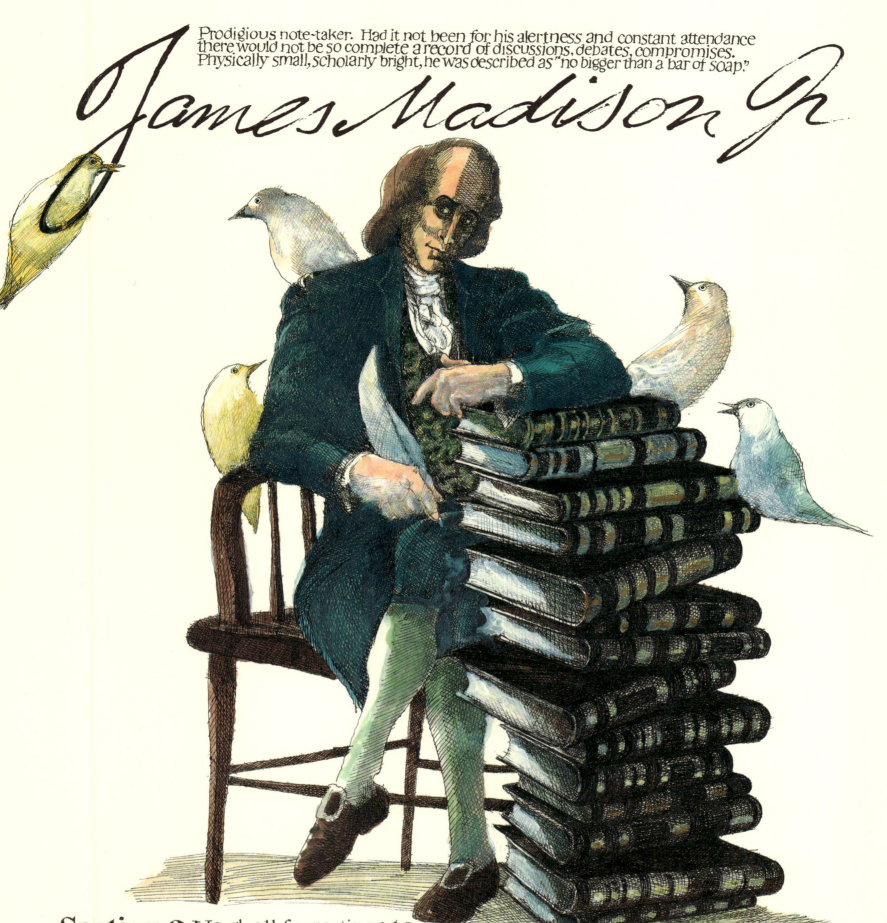

Prodigious note-taker. Had it not been for his alertness and constant attendance there would not be so complete a record of discussions, debates, compromises. Physically small, scholarly bright, he was described as "no bigger than a bar of soap."

James Madison Jr.

Section 3. He shall from time to time give to the Congress Information of the State of the Union, and recommend to their Consideration such Measures as he shall judge necessary and expedient; he may, on extraordinary Occasions, convene both Houses, or either of them, and in Case of Disagreement between them, with Respect to the Time of Adjournment, he may adjourn them to such Time as he shall think proper; he shall receive Ambassadors and other public Ministers; he shall take Care that Laws be faithfully executed, and shall Commission all the Officers of the United States.

Section 4. The President, Vice President and all civil Officers of the United States, shall be removed from Office on Impeachment for, and Conviction of, Treason, Bribery, or other high Crimes and Misdemeanors.

Article III

Section 1.
Section 2.

B. Franklin

Benjamin Franklin was in his eighty second year. Despite failing health he attended session after session and brought wisdom and calm to heated debates.

He said: "We are sent here to consult, not to contend with each other....

"Positiveness and warmth on one side naturally beget their like on the other; and tend to create and augment discord and division in a great concern, wherein harmony and union are extremely necessary to give weight to our councils, and render them effectual in promoting and securing the common good."

At a later session when progress was being made he remembered how delegates to the Continental Congress prayed for God's guidance for the revolution. It was in the room. He said: ".....I have lived a long time, and the longer I live, the more convincing proofs I see of this truth~
that God governs in the affairs of men?

Article III

Section 1. The Judicial Power of the United States shall be vested in one supreme Court, and in such inferior Courts as the Congress may from time to time ordain and establish. The Judges, both of the supreme and inferior Courts, shall hold their Offices during good Behavior; and shall, at stated Times, receive for their Services a Compensation which shall not be diminished during their Continuance in Office.
Section 2. The Judicial Power shall extend to all Cases, in Law and Equity, arising under this Constitution, the Laws of the United States, and Treaties made, or which shall be made, under their Authority;~

Article III
Section 2.
(continued)
Section 3.

;~ to all Cases affecting Ambassadors, other public Ministers and Consuls;~ to all Cases of admiralty and maritime Jurisdiction;~ to Controversies to which the United States shall be a Party;~ to Controversies between two or more States;~ between a State and Citizens of another State;~ between Citizens of different States;~ between Citizens of the same State claiming Lands under Grants of different States, and between a State, or the Citizens thereof, and foreign States, Citizens or Subjects.

In all Cases affecting Ambassadors, or other public Ministers and Consuls, and those in which a State shall be Party, the supreme Court shall have original Jurisdiction. In all other Cases before mentioned, the supreme Court shall have appellate Jurisdiction, both as to Law and Fact, with such Exceptions, and under such Regulations as the Congress shall make.

The trial of all Crimes, except in Cases of Impeachment, shall be by Jury; and such Trial shall be held in the State where the said Crimes shall have been committed; but when not committed within any State, the Trial shall be at such Place or Places as the Congress may by Law have directed.

Section 3. Treason against the United States, shall consist only in levying War against them, or in adhering to their Enemies, giving them Aid and Comfort. No Person shall be convicted of Treason unless on the Testimony of two witnesses to the same overt Act, or on Confession in open Court.

The Congress shall have power to declare the Punishment of Treason, but no Attainder of Treason shall work Corruption of Blood, or Forfeiture except during the Life of the Person attained.

Article IV

Section 1.
Section 2.

Article IV

Section 1.

Full Faith and Credit shall be given in each State to the public Acts, Records, and judicial Proceedings of every other State. And the Congress may by general Laws prescribe the Manner in which such Acts, Records and Proceedings shall be proved, and the Effect thereof.

Section 2.

The Citizens of each State shall be entitled to all Privileges and Immunities of Citizens in the several States.

A Person charged in any State with Treason, Felony, or other Crime, who shall flee from Justice, and be found in another State, shall on demand of the executive Authority of the State from which he fled, be delivered up, to be removed to the State having Jurisdiction of the Crime.

No Person held to Service or Labour in one State, under the Laws thereof, escaping into another, shall, in Consequence of any Law or Regulation therein, be discharged from such Service or Labour, but shall be delivered up on Claim of the Party to whom such Service or Labour may be due.

Article IV
Section 3.
Section 4.

STATEHOOD

Section 3. New States may be admitted by the Congress into this Union; but no new State shall be formed or erected within the Jurisdiction of any other State; nor any State be formed by the Junction of two or more States, or parts of States, without the Consent of the Legislatures of the States concerned as well as of the Congress.

The Congress shall have Power to dispose of and make all needful Rules and Regulations respecting the Territory or other Property belonging to the United States; and nothing in this Constitution shall be so construed as to Prejudice any Claims of the United States or of any particular State.

Section 4. The United States shall guarantee to every State in this Union a Republican Form of Government, and shall protect each of them against Invasion; and on Application of the Legislature, or of the Executive (when the Legislature cannot be convened) against domestic Violence.

Article V

The Constitution

Amendments

Article V

The Congress, whenever two thirds of both Houses shall deem it necessary, shall propose Amendments to this Constitution, or, on the Application of the Legislatures of two thirds of the several States, shall call a Convention for proposing Amendments, which, in either Case, shall be valid to all Intents and Purposes, as part of this Constitution, when ratified by the Legislatures of three fourths of of the several States, or by Conventions in three fourths thereof, as the one or the other Mode of Ratification may be proposed by the Congress; Provided that no Amendment which may be made prior to the Year One thousand eight hundred and eight shall in any Manner affect the first and fourth Clauses in the Ninth Section of the first Article; and that no State, without its Consent shall be deprived of its equal Suffrage in the Senate.

Glue of Good Government

Article VI

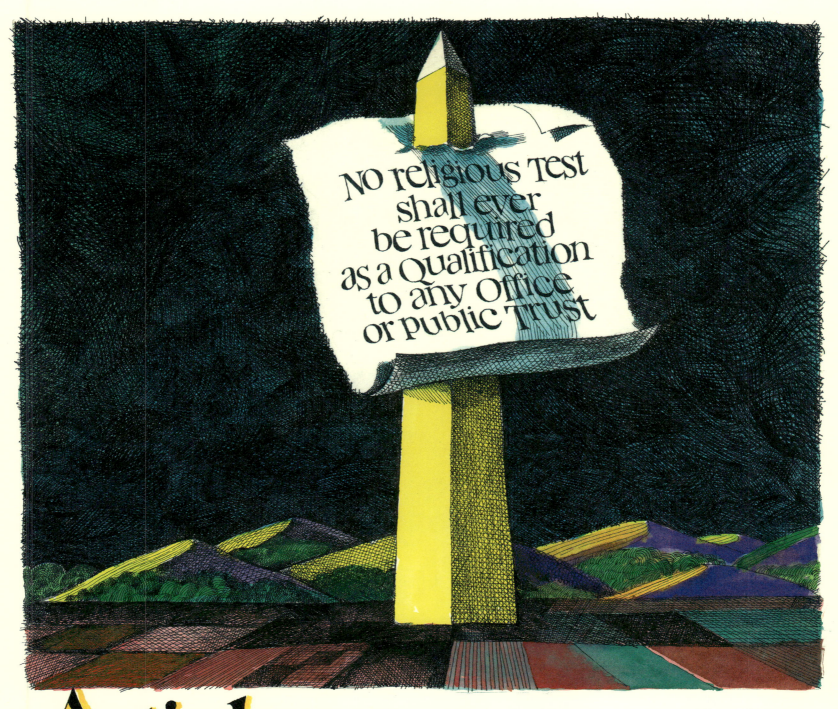

No religious Test shall ever be required as a Qualification to any Office or public Trust

Article VI

All Debts contracted and Engagements entered into, before the Adoption of this Constitution, shall be as valid against the United States under this Constitution, as under the Confederation.

This Constitution, and the Laws of the United States which shall be made in Pursuance thereof; and all Treaties made, or which shall be made, under the Authority of the United States, shall be the supreme Law of the Land; and the Judges in every State shall be bound thereby, any Thing in the Constitution or Laws of any State to the Contrary notwithstanding.

The Senators and Representatives before mentioned, and the Members of the several State Legislatures, and all executive and judicial Officers, both of the United States and of the several States, shall be bound by Oath or Affirmation, to support this Constitution; but no religious Test shall ever be required as a Qualification to any Office or public Trust under the United States.

Article VII

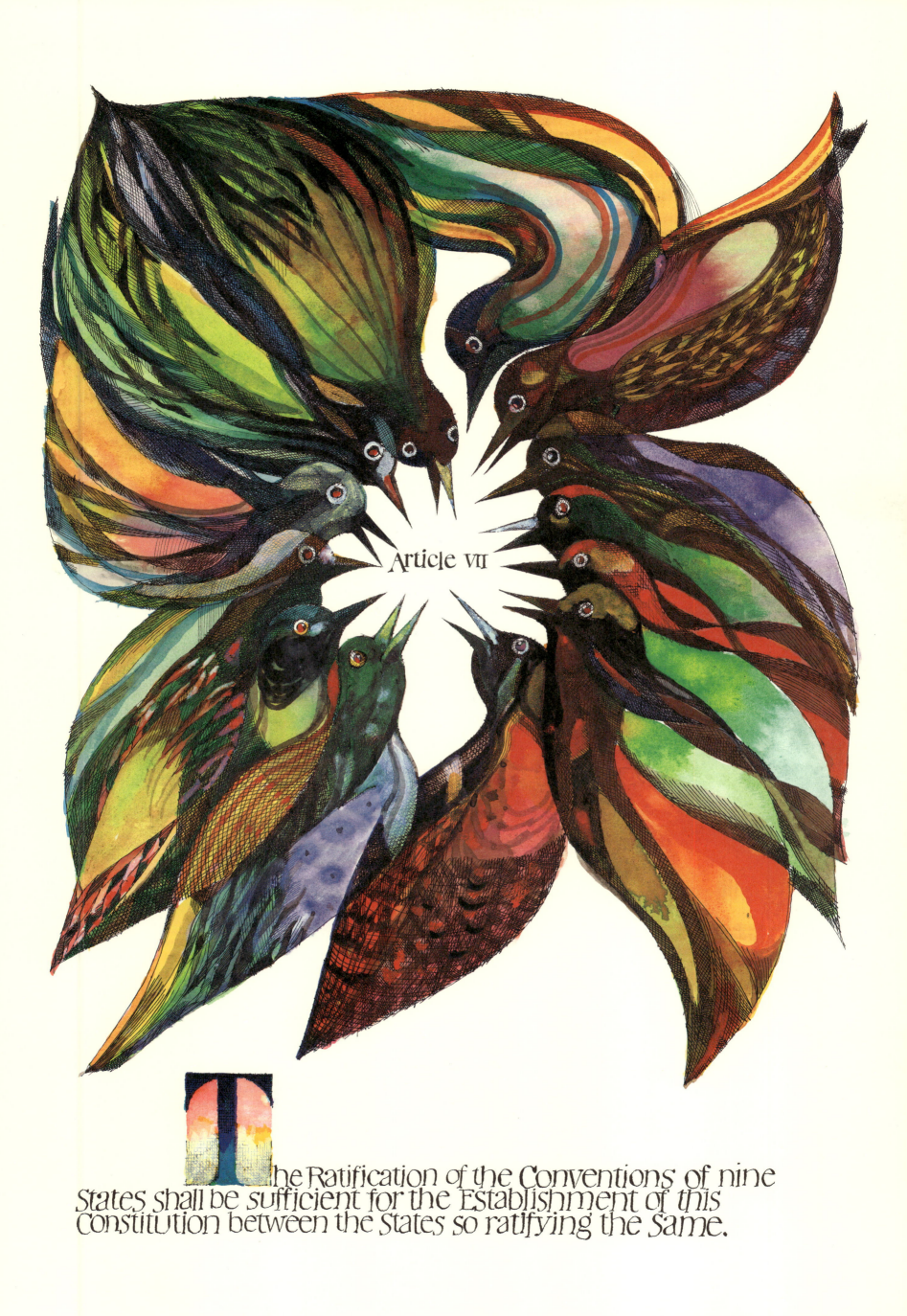

Article VII

The Ratification of the Conventions of nine States shall be sufficient for the Establishment of this Constitution between the States so ratifying the Same.

Signatures
of Signers

G. Washington—Presid.t. Geo: Read
Gunning Bedford jun John Dickinson Richard Bassett
Jaco: Broom James McHenry Dan: of St Thos Jenifer
Dan Carroll John Blair James Madison Jr.
W.m Blount Rich.d Dobbs Spaight Hu Williamson
J. Rutledge Charles Cotesworth Pinckney
Charles Pinckney Pierce Butler William Few
Abr Baldwin John Langdon Nicholas Gilman
Nathaniel Gorham Rufus King W.m Sam.l Johnson
Roger Sherman. Alexander Hamilton
Wil: Livingston David Brearley W.m Paterson
Jona: Dayton B Franklin Thomas Mifflin
Robt Morris Geo. Clymer Tho.s FitzSimons
Jared Ingersoll James Wilson Gouv Morris

attest William Jackson Secretary.

DONE

in Convention by the Unanimous
consent of the States present the Seventeenth Day of September in the Year of our Lord one thousand seven hundred and Eighty seven and of the Independence of the United States of America the Twelfth IN WITNESS whereof We have hereunto subscribed our Names.

Attest William Jackson, Secretary. Go. Washington–Presidt. and deputy from Virginia; New Hampshire: John Langdon, Nicholas Gilman.
Massachusetts: Nathaniel Gorham, Rufus King, Connecticut: Wm. Saml. Johnson. New York: Alexander Hamilton. New Jersey: Wil: Livingston, David Brearley, Wm. Paterson, Jona: Dayton. Pennsylvania: B. Franklin, Thomas Mifflin, Robt Morris, Geo. Clymer, Thos FitzSimons, Jared Ingersoll, James Wilson, Gouv Morris, Delaware: Geo: Read, Gunning Bedford jun, John Dickinson, Richard Bassett, Jaco: Broom. Maryland: James McHenry, Dan of St Thos Jenifer, Danl Carroll. Virginia: John Blair, James Madison Jr., North Carolina; Wm. Blount, Richd. Dobbs Spaight, Hu Williamson. South Carolina: J. Rutledge, Charles Cotesworth Pinckney, Charles Pinckney, Pierce Butler. Georgia: William Few, Abr Baldwin.
In Convention Monday, September 17th, 1787
Present The States of New Hampshire, Massachusetts, Connecticut, Mr. Hamilton from New York, New Jersey, Pennsylvania, Delaware, Maryland, Virginia, North Carolina, South Carolina, Georgia.

Resolved:

RESOLVED,

That the preceding Constitution be laid before the United States in Congress assembled, and that it is the Opinion of this Convention, that it should afterwards be submitted to a Convention of Delegates, chosen in each State by the People thereof, under the Recommendation of its Legislature, for their Assent and Ratification; and that each Convention assenting to, and ratifying the Same, should give Notice thereof to the United States in Congress assembled.

RESOLVED, That it is the Opinion of this Convention, that as soon as the Conventions of nine States shall have ratified this Constitution, the United States in Congress assembled should fix a Day on which Electors should be appointed by the States which shall have ratified the same, and a Day on which the Electors should assemble to vote for the President, and the Time and Place for commencing Proceedings under this Constitution. That after such Publication the Electors should be appointed, and the Senators and Representatives elected: That the Electors should meet on the Day fixed for the Election of the President, and should transmit their votes certified signed, sealed and directed, as the Constitution requires, to the Secretary of the United States in Congress assembled, that the Senators and Representatives should convene at the Time and Place assigned; that the Senators should appoint a President of the Senate, for the sole Purpose of receiving, opening and counting the Votes for President; and, that after he shall be chosen, the Congress, together with the President, should, without Delay, proceed to execute this Constitution.

By the Unanimous Order of the Convention.

William Jackson
secretary

G Washington
presidt.

Bill of Rights
Article I

F

ollowing are Articles in Addition to, and Amendment of, the Constitution of the United States of America, proposed by Congress and Ratified by the several States, pursuant to the fifth Article of the original Constitution. The first ten Amendments, *The Bill of Rights*, were added within two Years to guarantee individual liberties which were felt to be missing from the Constitution.

SOAP BOX

Article I

Congress shall make no law respecting an establishment of religion, or prohibiting the free exercise thereof; or abridging the freedom of speech, or of the press; or the right of the people peaceably to assemble, and to petition the Government for a redress of grievances.

Bill of Rights
Article II

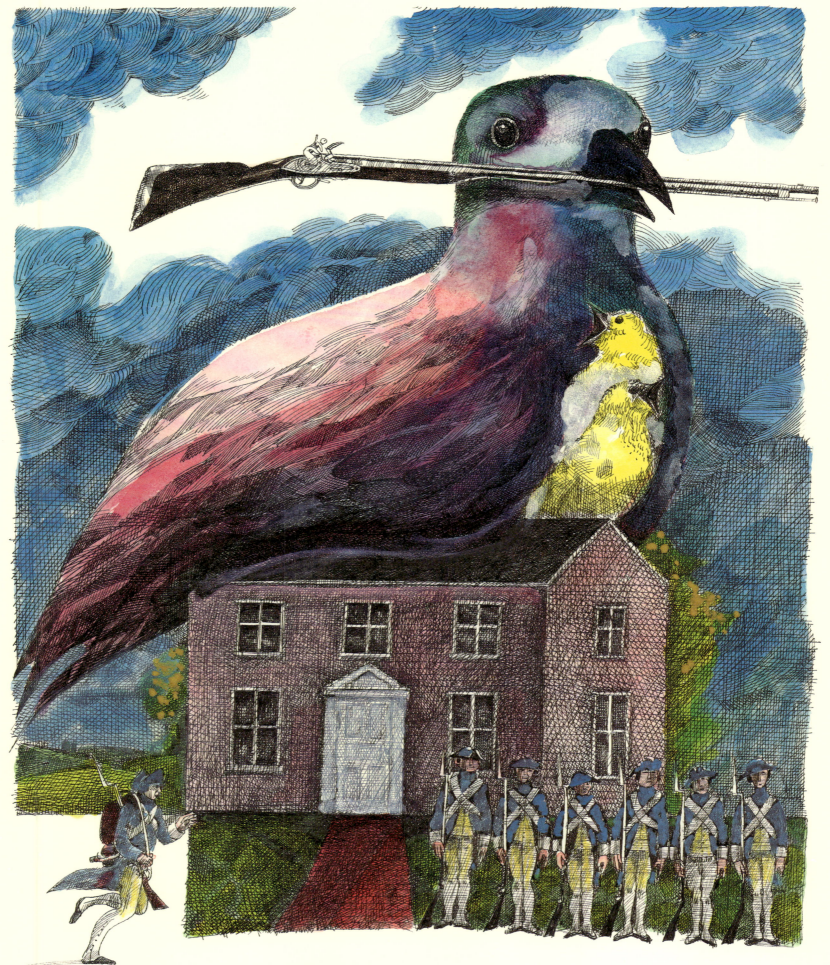

Article II

A well regulated Militia, being necessary to the security of a free State, the right of the people to keep and bear Arms, shall not be infringed.

Bill of Rights
Article III

Article III

No Soldier shall, in time of peace be quartered in any house, without the consent of the Owner, nor in time of war, but in a manner to be prescribed by law.

Bill of Rights
Article IV

Article IV

The right of the people to be secure in their persons, houses, papers, and effects, against unreasonable searches and seizures, shall not be violated, and no Warrants shall issue, but upon probable cause, supported by Oath or affirmation, and particularly describing the place to be searched, and the person or things to be seized.

Bill of Rights
Article V

Article V

No person shall be held to answer for a capital, or other~ wise infamous crime, unless on a presentment or indictment of a Grand Jury, except in cases arising in the land or naval forces, or in the Militia, when in actual service in time of War or public danger; nor shall any person be subject for the same offence to be twice put in jeopardy of life or limb; nor shall be compelled in any criminal case to be a witness against himself, nor be deprived of life, liberty, or property, without due process of law; nor shall private property be taken for public use, without just compensation.

Bill of Rights
Article VI

Article VI

In all criminal prosecutions, the accused shall enjoy the right to a speedy and public trial, by an impartial jury of the State and district wherein the crime shall have been committed, which district shall have been previously ascertained by law, and to be informed of the nature and cause of the accusation; to be confronted with the witnesses against him; to have compulsory process for obtaining witnesses in his favor, and to have the Assistance of Counsel for his defence.

Bill of Rights
Article VII

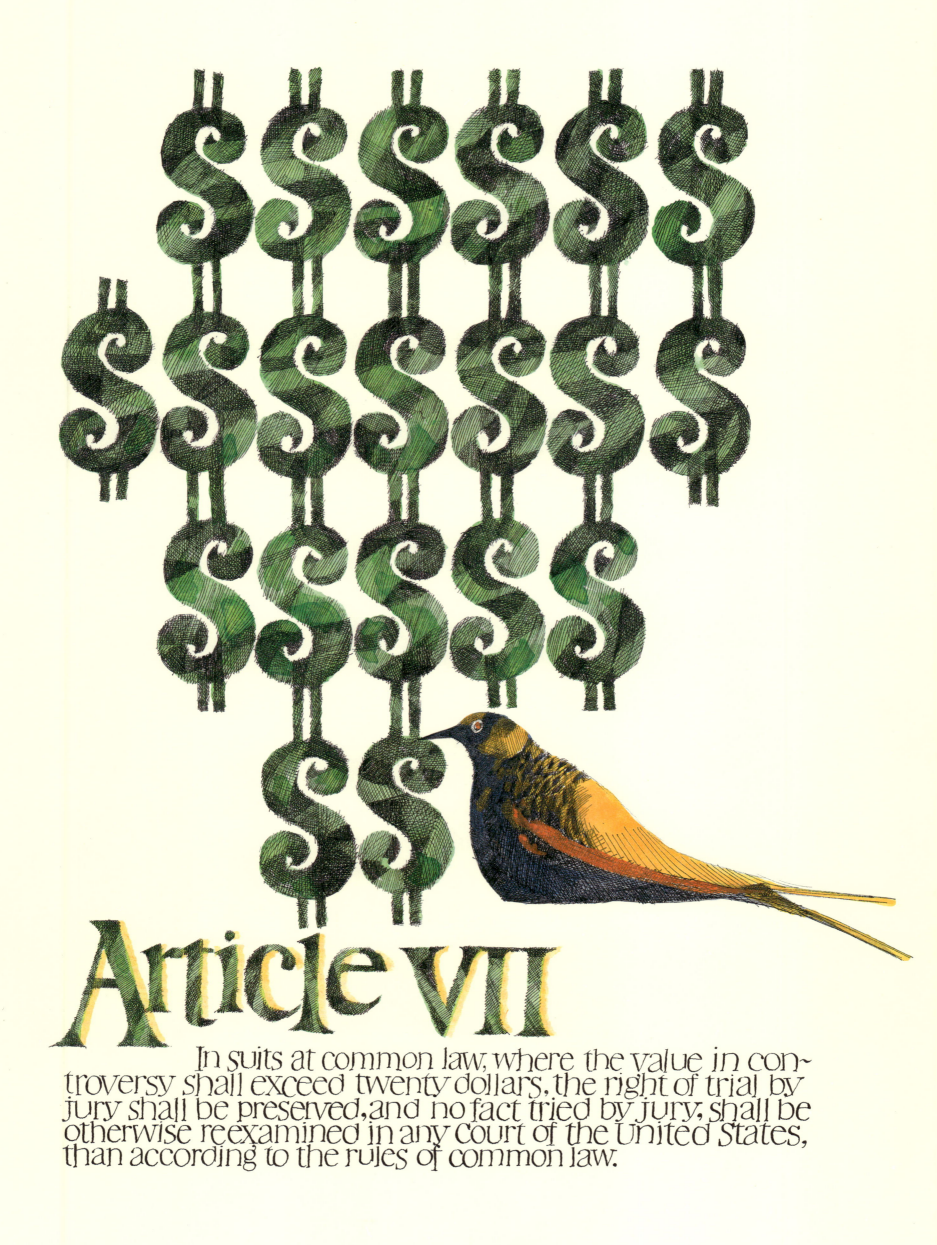

Article VII

In suits at common law, where the value in controversy shall exceed twenty dollars, the right of trial by jury shall be preserved, and no fact tried by jury, shall be otherwise reexamined in any court of the United States, than according to the rules of common law.

Bill of Rights
Article VIII

Article VIII

Excessive bail shall not be required, nor excessive fines imposed, nor cruel and unusual punishments inflicted.

Bill of Rights
Article IX

Article IX

The enumeration in the Constitution, of certain rights, shall not be construed to deny or disparage others retained by the people.

THE RIGHTS of the PEOPLE

Bill of Rights
Article X

Article X

The powers not delegated to the United States by the Constitution, nor prohibited by it to the States, are reserved to the States respectively, or to the people.

Amendment XI

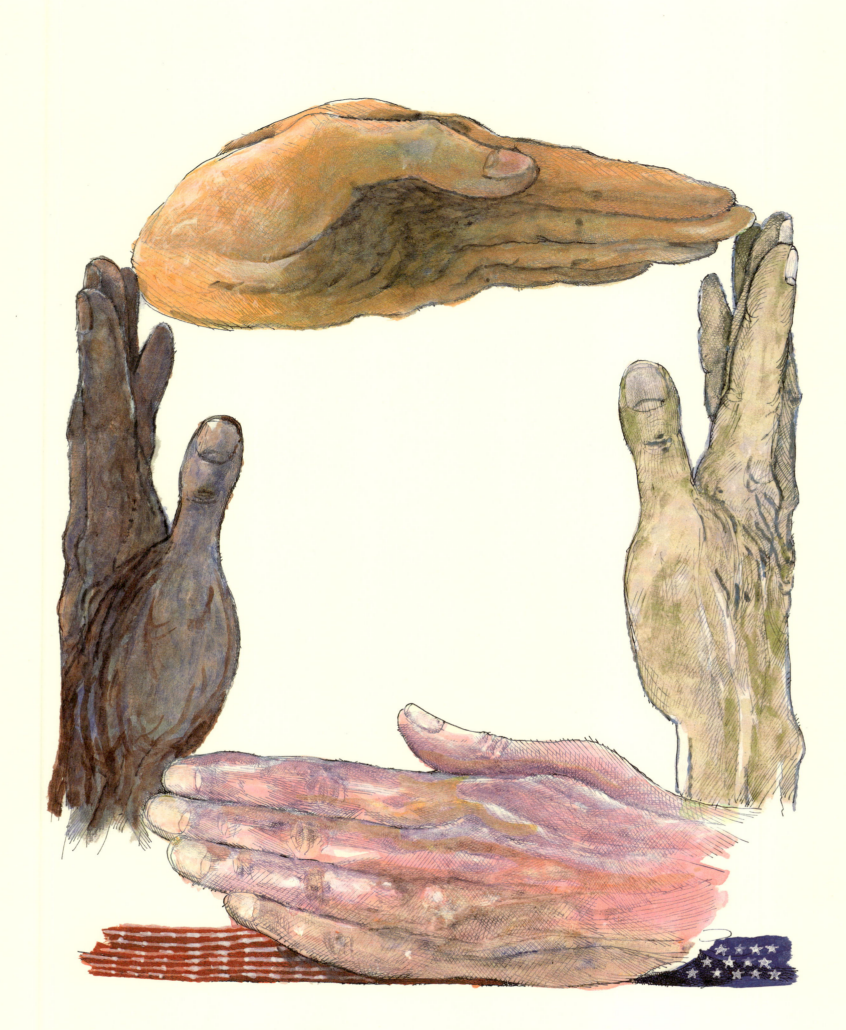

Amendment XI ‖1798‖

The Judicial power of the United States shall not be construed to extend to any suit in law or equity, commenced or prosecuted against one of the United States by Citizens of another State, or by Citizens or Subjects of any Foreign State.

Amendment XII

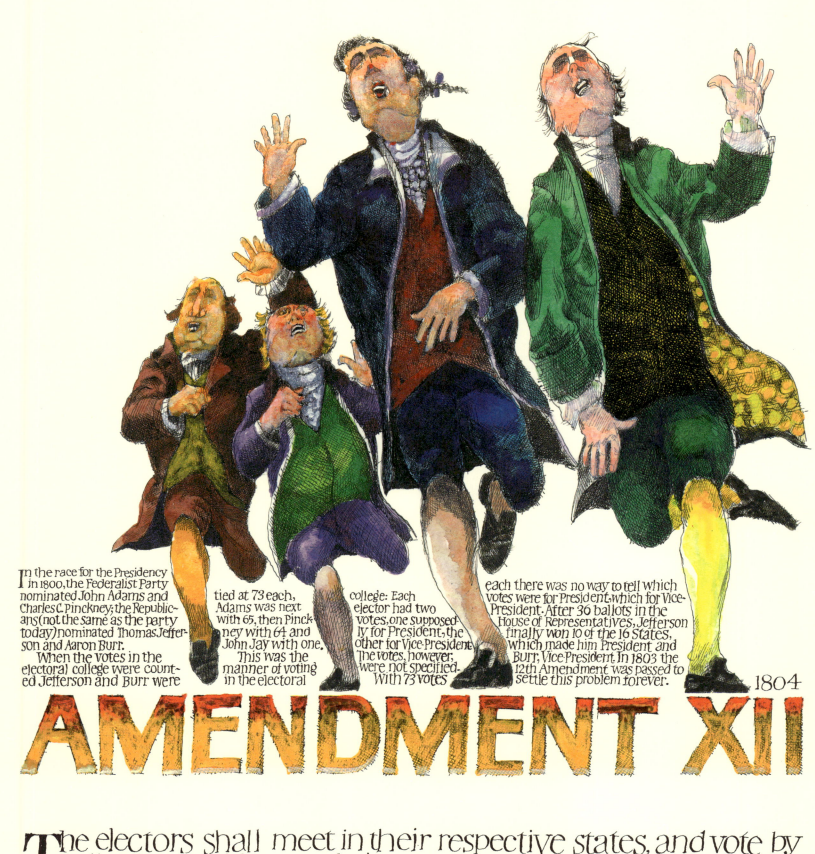

In the race for the Presidency in 1800, the Federalist Party nominated John Adams and Charles C. Pinckney; the Republicans (not the same as the party today) nominated Thomas Jefferson and Aaron Burr.

When the votes in the electoral college were counted Jefferson and Burr were tied at 73 each, Adams was next with 65, then Pinckney with 64 and John Jay with one. This was the manner of voting in the electoral college: Each elector had two votes, one supposedly for President, the other for Vice-President. The votes, however, were not specified. With 73 votes each there was no way to tell which votes were for President, which for Vice-President. After 36 ballots in the House of Representatives, Jefferson finally won 10 of the 16 States, which made him President and Burr, Vice-President. In 1803 the 12th Amendment was passed to settle this problem forever.

1804

AMENDMENT XII

The electors shall meet in their respective states, and vote by ballot for President and Vice-President, one of whom, at least, shall not be an inhabitant of the same state with themselves; they shall name in their ballots the person voted for as President, and in distinct ballots the person voted for as Vice-President, and they shall make distinct lists of all persons voted for as President, and of all persons voted for as Vice-President, and of the number of votes for each, which lists they shall sign and certify, and transmit sealed to the seat of the government of the United States, directed to the President of the Senate;
— The President of the Senate shall, in the presence of the Senate and House of Representatives, open all the certificates and the votes shall then be counted;
— The person having the greatest number of votes for President, shall be President, if such number be a majority of the whole number of Electors appointed; and if no person have such majority, then from the persons having the highest numbers not exceeding three on the list of those voted.......

Amendment XII
(continued)

····for as President, the House of Representatives shall choose immediately, by ballot, the President. But in choosing the President, the votes shall be taken by states, the representation from each state having one vote; a quorum for this purpose shall consist of a member or members from two-thirds of the states, and a majority of all the States shall be necessary to a choice. And if the House of Representatives shall not choose a President whenever the right of choice shall devolve upon them, before the fourth day of March next following, then the Vice-President shall act as President, as in the case of the death or other constitutional disability of the President.

——The person having the greatest number of votes as Vice-President, shall be the Vice-President, if such number be a majority of the whole number of Electors appointed, and if no person have a majority, then from the two highest numbers on the list, the Senate shall choose the Vice-President; a quorum for the purpose shall consist of two-thirds of the whole number of Senators, and a majority of the whole number shall be necessary to a choice. But no person constitutionally ineligible to the office of President shall be eligible to that of Vice-President of the United States.

ONE VOTE for PRESIDENT

ONE VOTE for VICE-PRESIDENT

Amendment XIII

Amendment XIII 1865

Section 1. Neither slavery nor involuntary servitude, except as punishment for crime whereof the party shall have been duly convicted, shall exist within the United States, or any place subject to their jurisdiction.

Section 2. Congress shall have power to enforce this article by appropriate legislation.

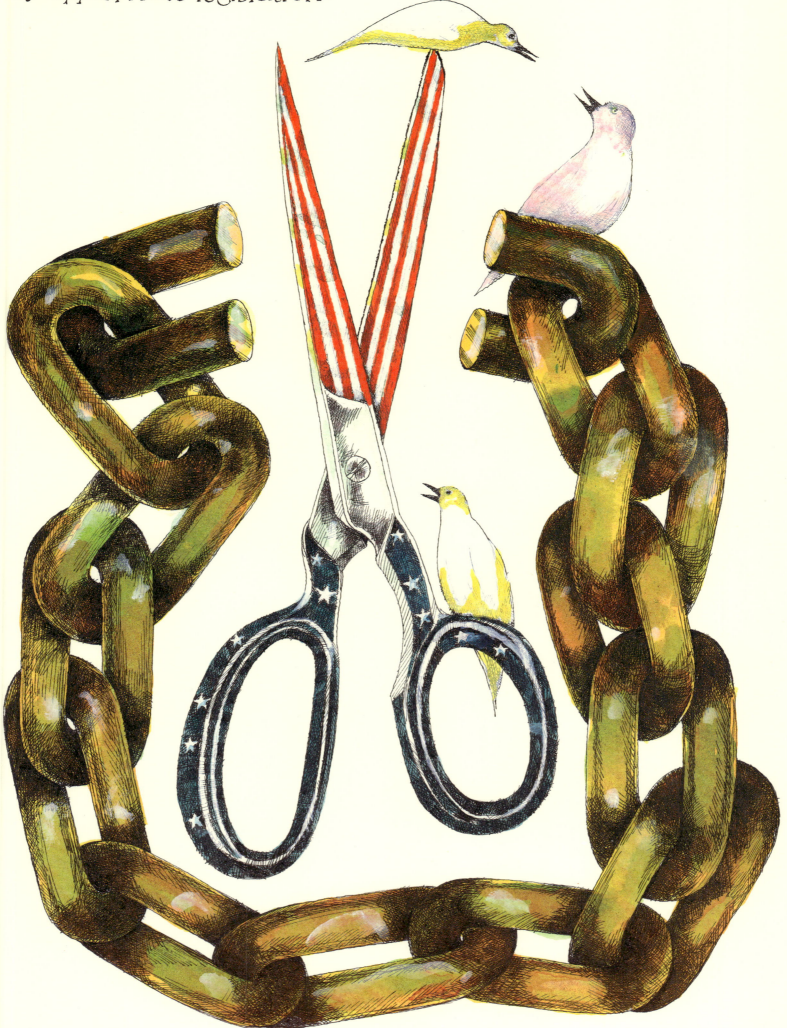

Amendment XIV

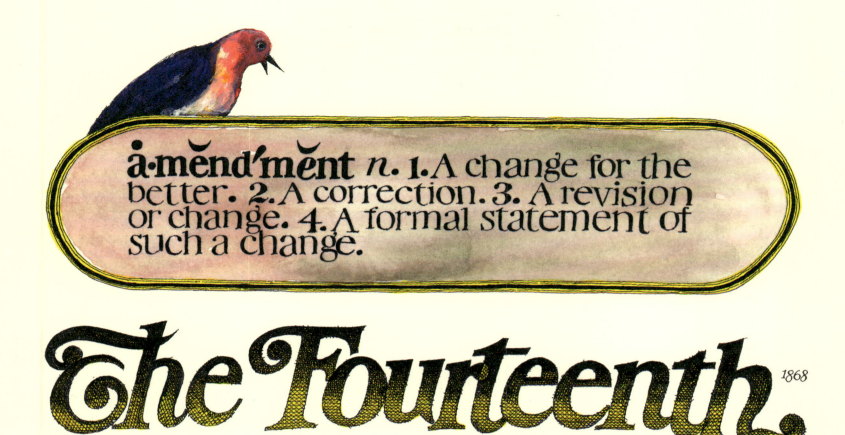

a·mend′ment *n.* 1. A change for the better. 2. A correction. 3. A revision or change. 4. A formal statement of such a change.

The Fourteenth. 1868

Section 1. All persons born or naturalized in the United States, and subject to the jurisdiction thereof, are citizens of the United States and of the State wherein they reside. No State shall make or enforce any law which shall a~ bridge the privileges or im~ munities of citizens of the United States; nor shall any State deprive any person of life, liberty, or property, without due process of law; nor deny to any person within its jurisdiction the equal pro~ tection of the laws.

Section 2. Represent~ atives shall be appor~ tioned among the several States ac~ cording to their respec~ tive numbers, counting the whole number of persons in each State, excluding Indians not taxed. But when the right to vote at any election for the choice of electors for President and Vice-President of the United States, Represent~ atives in Congress, the Executive and Judicial officers of a State, or the members of the Legislature thereof, is denied to any of the male inhabitants of such State, being twenty~one years of age, and citizens of the United States, or in any way abridged, except for participation in rebellion, or other crime, the basis of representation therein shall be reduced in the proportion which the number of such male citizens shall bear to the whole number of male citizens twenty~one years of age in such State.

Amendment XIV
(continued)

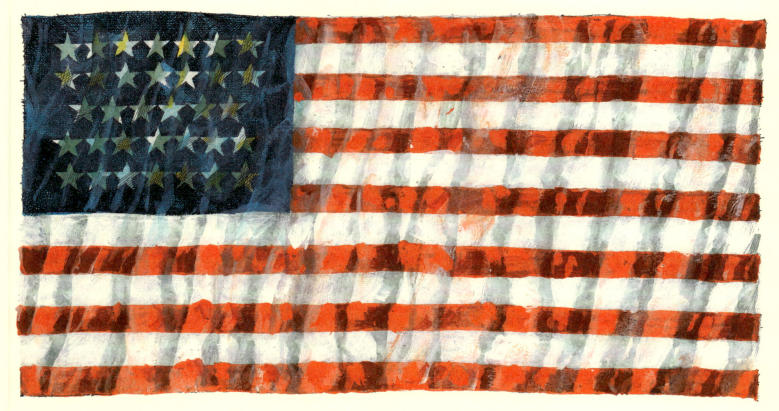

The fifth flag of the Nation. It wears 34 stars, yet there were 37 states in the Nation. The next flag, adopted in 1896 showed 45 stars. These are the States of the Nation in 1868 and the dates of joining: New Jersey, Pennsylvania, Delaware...1787; New Hampshire, Massachusetts, Connecticut, New York, Maryland, Virginia, South Carolina, Georgia...1788; North Carolina 1789; Rhode Island 1790; Vermont 1791; Kentucky 1792; Tennessee 1796; Ohio 1803; Louisiana 1812; Indiana 1816; Mississippi 1817; Illinois 1818; Alabama 1819; Maine 1820; Missouri 1821; Arkansas 1836; Michigan 1837; Texas, Florida 1845; Iowa 1846; Wisconsin 1848; California 1850; Minnesota 1858; Oregon 1859; Kansas 1861; West Virginia 1863; Nevada 1864; Nebraska 1867.

Fourteenth Amendment (continued)

Section 3. No person shall be a Senator or Representative in Congress, or elector of President and Vice-President, or hold any office, civil or military, under the United States, or under any State, who, have previously taken an oath, as a member of Congress, or as an officer of the United States, or as a member of any State legislature, or as an executive or judicial officer of any State, to support the Constitution of the United States, shall have engaged in insurrection or rebellion against the same, or given aid or comfort to the enemies thereof. But Congress may by a vote of two-thirds of each House, remove such disability.

Section 4. The validity of the public debt of the United States, authorized by law, including debts incurred for payment of pensions and bounties for services in suppressing insurrection or rebellion, shall not be questioned. But neither the United States nor any State shall assume or pay any debt or obligation incurred in aid of insurrection or rebellion against the United States, or any claim for the loss or emancipation of any slave; but all such debts, obligations and claims shall be held illegal and void.

Section 5. The Congress shall have power to enforce, by appropriate legislation, the provisions of this article.

ULYSSES S. GRANT
Eighteenth President, 1869-1877

Amendment XV

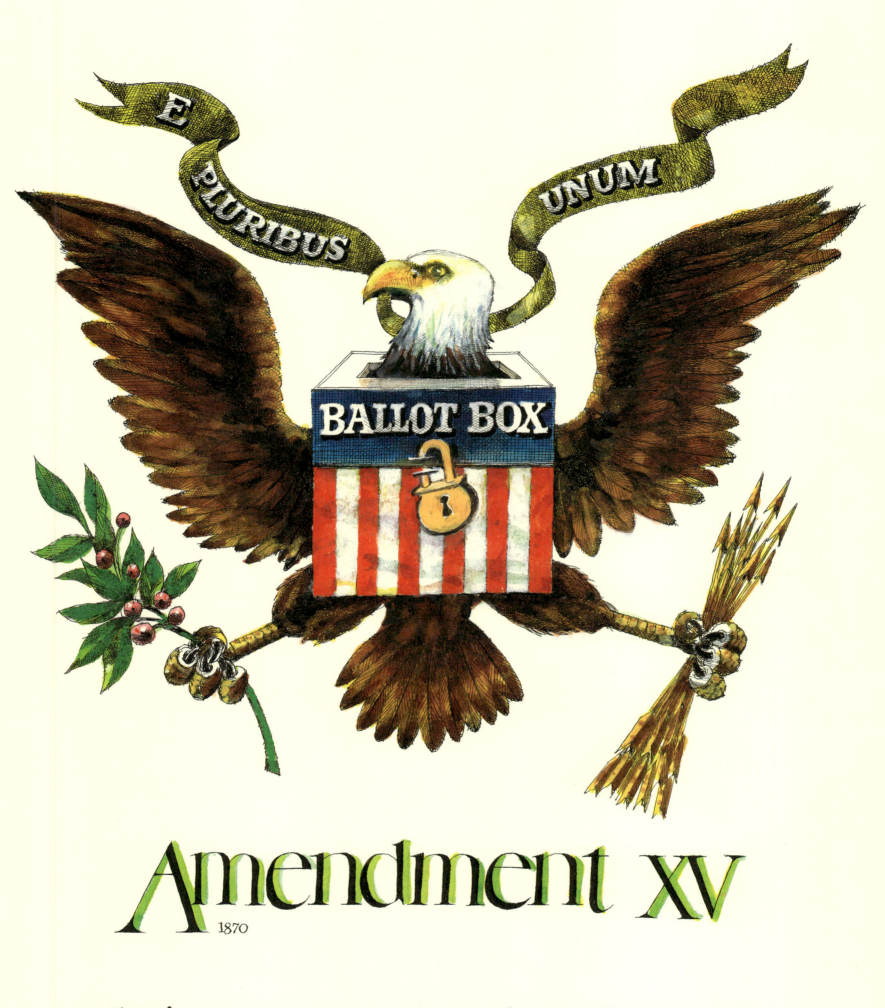

Amendment XV
1870

Section 1. The right of citizens of the United States to vote shall not be denied or abridged by the United States or by any State on account of race, color, or previous condition of servitude—

Section 2. The Congress shall have power to enforce this article by appropriate legislation.

Amendment XVI

Amendment XVI 1913

The Congress shall have power to lay and collect taxes on incomes, from whatever source derived, without apportionment among the several States, and without regard to any census or enumeration.

Amendment XVII

Amendment XVII 1913

The Senate of the United States shall be composed of two Senators from each State, elected by the people thereof, for six years; and each Senator shall have one vote. The electors in each State shall have the qualifications requisite for electors of the most numerous branch of State legislatures.

When vacancies happen in the representation of any State in the Senate, the executive authority of such State shall issue writs of election to fill such vacancies: *Provided*, That the legislature of any State may empower the executive thereof to make temporary appointments until the people fill the vacancies by election as the legislature may direct.

This amendment shall not be so construed as to affect the election or term of any Senator chosen before it becomes valid as part of the Constitution.

Amendment XVIII

Amendment XVIII 1919

Section 1. After one year from the ratification of this article the manufacture, sale, or transportation of intoxicating liquors within, the importation thereof into, or the exportation thereof from the United States and all territory subject to the jurisdiction thereof for beverage purposes is hereby prohibited.

Section 2. The Congress and the several States shall have concurrent power to enforce this article by appropriate legislation.

Section 3. This article shall be inoperative unless it shall have been ratified as an amendment to the Constitution by the legislatures of the several States, as provided in the Constitution, within seven years from the date of submission hereof to the States by the Congress.

Amendment XIX

Amendment XIX 1920

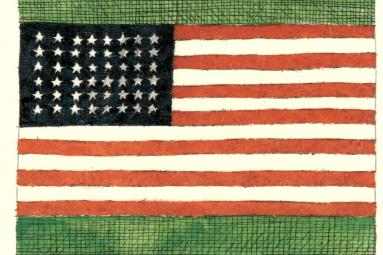

The right of citizens of the United States to vote shall not be denied or abridged by the United States or by any State on account of sex.

Congress shall have power to enforce this article by appropriate legislation.

Amendment XX
Section 1.
Section 2.

Amendment XX 1933

Section 1. The terms of the President and Vice President shall end at noon on the 20th day of January, and the terms of Senators and Representatives at noon on the 3d day of January, of the years in which such terms would have ended if this article had not been ratified; and the terms of their successors shall then begin.

Section 2. The Congress shall assemble at least once in every year, and such meeting shall begin at noon on the 3d day of January, unless they shall by law appoint a different day.

Amendment XX
Section 3.
Section 4.
Section 5.

Section 3. If, at the time fixed for the beginning of the term of the President, the President elect shall have died, the Vice President elect shall become President. If a President shall not have been chosen before the time fixed for the beginning of his term, or if the President elect shall have failed to qualify, then the Vice President elect shall act as President until a President shall have qualified; and the Congress may by law provide for the case wherein neither a President elect nor a Vice President elect shall have qualified, declaring who shall then act as President, or the manner in which one who is to act shall be selected, and such person shall act accordingly until a President or Vice President shall have qualified.

Section 4. The Congress may by law provide for the case of the death of any persons from whom the House of Representatives may choose a President whenever the right of choice shall have devolved upon them, and for the case of the death of any of the persons from whom the Senate may choose a Vice President whenever the right of choice shall have devolved upon them.

Section 5. Sections 1 and 2 shall take effect on the 15th day of October following the ratification of this article.

Section 6. This article shall be inoperative unless it shall have been ratified as an amendment to the Constitution by the legislatures of three-fourths of the several States within seven years from the date of its submission.

Amendment XXI

Amendment XXI 1933

Section 1. The eighteenth article of amendment to the Constitution of the United States is hereby repealed.

Section 2. The transportation or importation into any State, Territory, or possession of the United States for delivery or use therein of intoxicating liquors, in violation of the laws thereof, is hereby prohibited.

Section 3. This article shall be inoperative unless it shall have been ratified as an amendment to the Constitution by conventions in the several States, as provided in the Constitution, within seven years from the date of submission hereof to the States by Congress.

Amendment XXII
Section 1.
Section 2.

Section 1. No person shall be selected to the office of the President more than twice, and no person who has held the office of President, or acted as President, for more than two years of a term to which some other person was elected President shall be elected to the office of the President more than once. But this Article shall not apply to any person holding the office of President when this Article was proposed by the Congress, and shall not prevent any person who may be holding

the office of President, or acting as President, during the term within which this Article becomes operative from holding the office of President or acting as President during the remainder of such term.

Section 2. This article shall be inoperative unless it shall have been ratified as an amendment to the Constitution by the legislatures of three-fourths of the several States within seven years from the dates of its submission to the States by the Congress.

He was known as FDR,
32nd President, originator of the
"fire-side chat" and the phrase
"we have nothing to fear but fear itself."
Franklin Delano Roosevelt,
the one and only four term President,
served from 1933 to 1945.
He died shortly after he began
his fourth term.

Amendment XXIII
 Section 1.
 Section 2.

Amendment XXIII

1961

Section 1. The District constituting the seat of the Government of the United States shall appoint in such manner as the Congress may direct:

A number of electors of President and Vice President equal to the whole number of Senators and Representatives in Congress to which the District would be entitled if it were a State, but in no event more than the least populous State; they shall be in addition to those appointed by the States, but they shall be considered, for the purposes of the election of President and Vice President, to be electors appointed by a State; and they shall meet in the District and perform such duties as provided by the twelfth article of amendment.

Section 2. The Congress shall have power to enforce this article by appropriate legislation.

THE DISTRICT

Amendment XXIV

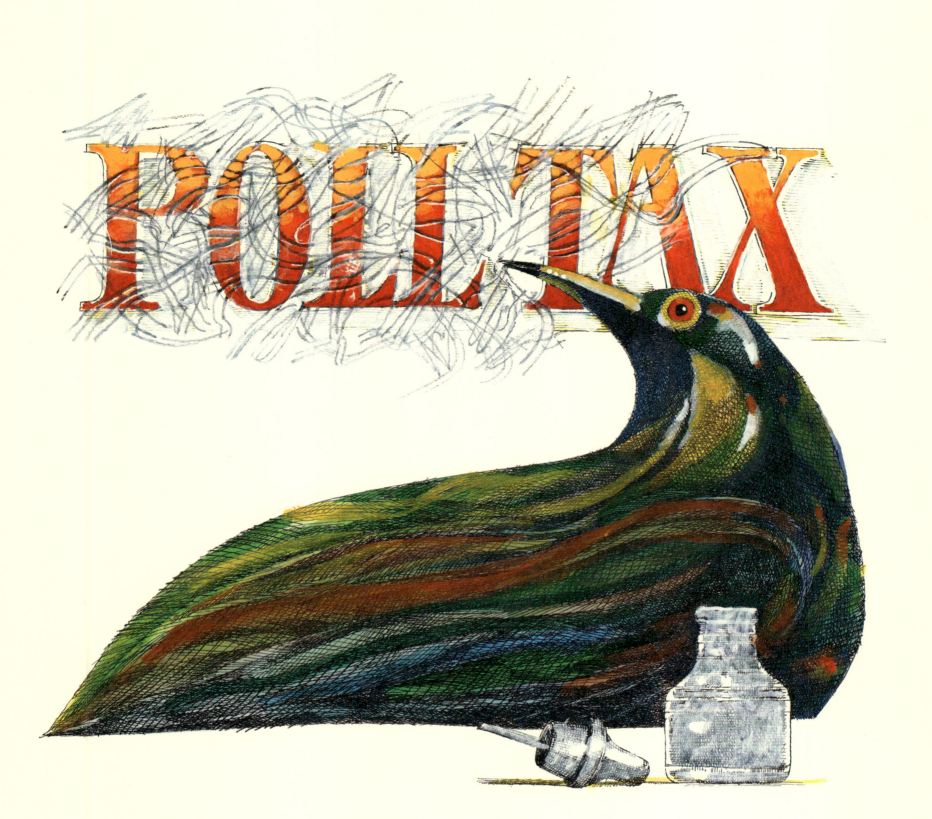

POLL TAX

Amendment XXIV 1964

Section 1. The right of citizens of the United States to vote in any primary or other election for President or Vice President, for electors for President or Vice President, or for Senator or Representative in Congress, shall not be denied or abridged by the United States or any State by reason of failure to pay any poll tax or other tax.

Section 2. The Congress shall have power to enforce this article by appropriate legislation.

Amendment xxv

Section 1.
Section 2.
Section 3.
Section 4.

Presidents James Garfield, Woodrow Wilson, Dwight Eisenhower all had periods of time when they were unable to handle the duties of office. Garfield was shot and critically wounded. Wilson suffered a stroke…recovered. Eisenhower had a heart attack from which he too recovered.

Amendment XXV ¹⁹⁶⁷

Section 1. In case of the removal of the President from office or of his death or resignation, the Vice President shall become President.

Section 2. Whenever there is a vacancy in the office of the Vice President, the President shall nominate a Vice President who shall take office upon confirmation by a majority vote of both Houses of Congress.

Section 3. Whenever the President transmits to the President pro tempore of the Senate and the Speaker of the House of Representatives his written declaration that he is unable to discharge the powers and duties of his office, and until he transmits to them a written declaration to the contrary, such powers and duties shall be discharged by the Vice President as Acting President.

Section 4. Whenever the Vice President and a majority of either the principal officers of the executive departments or of such other body as Congress may by law provide, transmit to the

Amendment XXV
Section 4.
(continued)

hip bone

thigh bone

knee bone

shin bone

ankle bone

foot bone

President pro tempore of the Senate and the Speaker of the House of Representatives their written declaration that the President is unable to discharge the powers and duties of his office, the Vice President shall immediately assume the powers and duties of the office as Acting President.

Thereafter, when the President transmits to the President pro tempore of the Senate and the Speaker of the House of Representatives his written declaration that no inability exists, he shall resume the powers and duties of his office unless the Vice President and a majority of either the principal officers of the executive department or of such other body as Congress may by law provide, transmit within four days to the President pro tempore of the Senate and the Speaker of the House of Representatives their written declaration that the President is unable to discharge the powers and duties of his office. Thereupon Congress shall decide the issue, assembling within forty-eight hours for that purpose if not in session. If the Congress, within twenty-one days after receipt of the latter written declaration, or if Congress is not in session, within twenty-one days after Congress is required to assemble, determines by two-thirds vote of both Houses that the President is unable to discharge the powers and duties of his office, the Vice President shall continue to discharge the same as Acting President; otherwise, the President shall resume the powers and duties of his office.

❋"The foot bone is connected to the ankle bone; the ankle bone is connected to the shin bone; the shin bone is connected to knee bone; the knee bone is connected to the thigh bone; and the thigh bone is connected to the hip bone... Now hear the word of the LORD...."

Amendment XXVI

Amendment XXVI

1971

The right of citizens of the United States, who are 18 years, or older, to vote shall not be denied or abridged by the United States or by any state on account of age. The Congress shall have the power to enforce this article by appropriate legislation.

Amendment XXVII

Amendment XXVII

1992

No law, varying the compensation for the services of the Senators and Representatives shall take effect, until an election of Representatives shall have intervened.

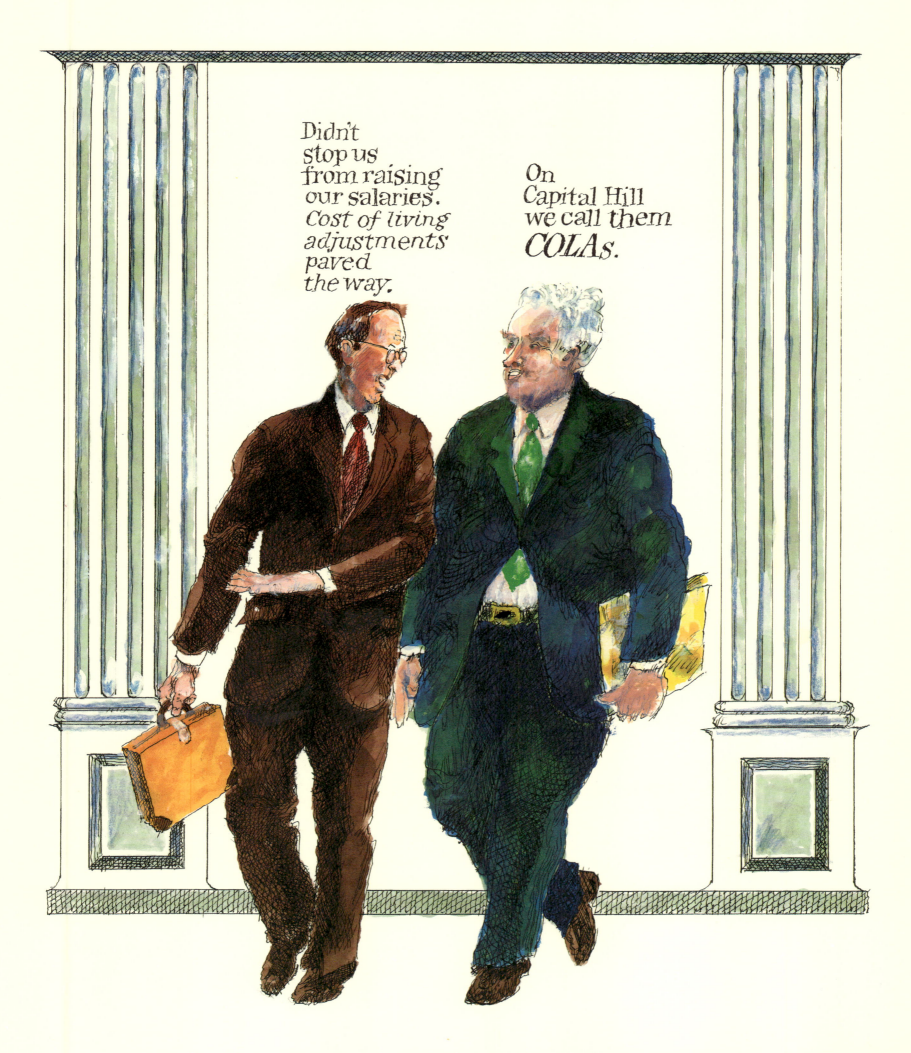

Didn't stop us from raising our salaries. *Cost of living adjustments paved the way.*

On Capital Hill we call them *COLAs.*

CHRONOLOGY

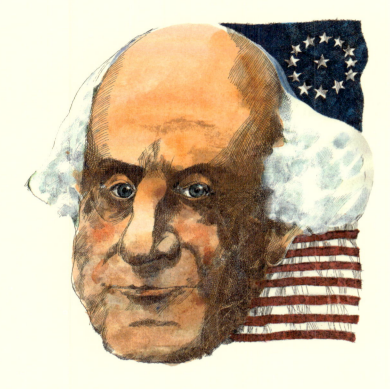

The Annapolis Convention assembles. At the urging of Virginian James Madison, a national conference is called to discuss the fledgling nation's problems with commerce—the main concern being that the national government has no authority to regulate trade among states. However, when Madison arrives in Annapolis, he discovers that only Delaware, New Jersey, New York, Pennsylvania, and Virginia have sent delegates, and only the first three states arrived with enough delegates to achieve a quorum and enable them to speak for their respective states.

Without the ability to hold an official conference on commerce, those in Annapolis [including Alexander Hamilton (NY) and George Reed (DE)] utilize the time to discuss and debate the current state of the federal government—one that most were dissatisfied with. After three days, a decision is made to request that Congress call for a larger convention to be held the following summer in Philadelphia, where all 13 states (Connecticut, Delaware, Georgia, Massachusetts, Maryland, New Hamshire, New Jersey, New York, North Carolina, Pennsylvania, Rhode Island, South Carolina, and Virginia) could participate in a broad discussion on amending the Articles of Confederation.

February 21, 1787

Congress approves the Constitutional Convention and sets a date for May 14, 1787, with "the sole and express purpose of revising the Articles of Confederation."

May 3

James Madison arrives early in Philadelphia to work on his thoughts and to plan for the convention.

May 13

George Washington arrives in Philadelphia.

May 14

The Constitutional Convention is postponed due to a failure to reach voting quorum. The Virginia delegation gathers to discuss an overall blueprint for the Confederation, later referred to as the Virginia Plan. Madison's ideas are the basis for this plan, in which the states become a republic with a strong national government that is essentially run by the people.

May 25

Almost two weeks later than scheduled, the Constitutional Convention achieves quorum with seven states' delegations present (DE, NC, NJ, NY, PA, SC, and VA). Between this time and July 23, all 13 states, except Rhode Island, will achieve voting quorum, though not all states will maintain their quorum throughout the entire convention. General orders of business are attended to during the first days in Philadelphia, with the delegations unanimously electing George Washington president of the convention and a committee of Alexander Hamilton, Charles Pinckney (SC), and George Wythe (VA) to prepare the rules of the convention. It is agreed among other things that: the deliberations at the convention will be kept secret, each state will receive one vote, the issues at hand can be resolved by the states present but with the provision that delegates can request a return to any of the issues already voted on later in the convention.

May 29

Virginia's governor, Edmund Randolph, presents the Virginia Plan. Included in this plan are 15 resolutions that propose creating a three-branch (executive, judiciary, legislative) national government. Concerning the legislative branch, the plan proposes a national legislature with two houses or chambers in which the states' representation would be determined proportionately according to their free population. The first house (Congress) to be elected by the people, was subject to recall and rotation, and elects the representatives to the second house (Senate). Both houses would be able to originate legislation. One of the plan's most controversial

proposed resolutions was that the national legislature would have the power to veto any state legislation that was deemed unconstitutional.

Under the Virginia Plan a national executive was to be chosen by the legislative branch and, sensitive to the fears of another monarchy, the executive was to be ineligible for reelection. The national judiciary branch would contain a supreme court that served for life and inferior courts to serve the states. The judiciary branch would have the ability to impeach national officers and to deal with questions involving national peace and security. The executive and judiciary branches would also be given the right to form councils in order to consider and veto any bills passed by the legislative branch.

After the Virginia Plan, Charles Pinckney presents his own plan (The Pinckney Plan), which does not receive the support of the convention.

Debate around the Virginia Plan begins, and the committee of the whole (all delegates present at the convention) resolves to establish a national government with supreme executive, judiciary, and legislative branches.

May 31

Representation in the national legislature is debated, but the Delaware delegates make it clear that they have been instructed to leave the convention if the equality of votes, as provided for in the Articles of the Confederation, is changed.

The decision to establish a bicameral legislature is reached, and the debate begins over how the two houses are to be elected. It is agreed that the people should elect the first house, but many are wary about giving the people, many of whom are uneducated, the power to elect representatives to both houses.

June 1–4

The question of executive power is raised. Should it be a single person or a group? Should the people or the legislature elect the executive?

A single executive is approved and given "executive power" that can only be overridden by a two-thirds majority in the legislature.

June 6

Pinckney asks the delegates to reconsider the method of election for Congress, saying representatives should be elected by the states' legislatures in order for each

individual state to maintain power over the federal government. Madison stands for a popular election, arguing that the more people that are involved in the political system, the less opportunity there is for one group to rule and oppress others. After a vote, popular election for Congress wins the majority.

June 11

After more debate about representation in Congress, the convention comes to a deadlock. Smaller states want equal representation whereas the larger states argue that all representation should be based on population. This highlights the large divide between Federalists and Anti-Federalists—should the new government be focused on the states' needs or individuals' needs?

Roger Sherman (CT) proposes the Great Compromise in which representation in Congress is based on state population (giving the larger states more elected representatives), while the Senate gives two votes for each state (allowing for each state, no matter the size, to have an equal amount of elected representatives).

June 13

The committee of the whole presents an amended version of the Virginia Plan, now with 19 resolutions. There is an adjournment for an alternate plan to be prepared.

June 15

William Paterson proposes the New Jersey Plan. Those who want to protect state sovereignty and who believe the convention's sole purpose is to *amend* the Articles of the Confederation support the plan. Its nine resolutions provide that the existing Congress has the power to control federal taxes, importation, and the right to appoint an executive who, in turn, would have the ability to compel the states to obey any federal laws passed by Congress. A supreme judicial court would rule on foreign affairs, treaties, and federal trade.

June 18

Alexander Hamilton proposes his own plan based on the British Constitution. This plan proposes an elected assembly serving three-year terms, and an executive who would serve for life and have absolute veto. The Senate would be the strongest component, serving life terms with the power to declare war, elect judges to serve in state courts, and elect state governors.

June 19

Madison asks the convention to return to the Virginia Plan, fearing that anything other than an absolute overhaul of the Articles of Confederation will result in 13 completely sovereign states, with the smaller and weaker states being unable to protect themselves against their larger neighbors or that the nation's 13 states would divide into two or more smaller confederacies. The committee of the whole votes to return to the Virginia Plan.

July 14

Sherman's Great Compromise as proposed on June 11 is amended and approved.

July 17–19

Debate returns to the manner of electing the executive. A concern is raised that, if elected by the legislative branch, the executive would simply serve the needs of the legislature, but others argue that the size of the country would make it nearly impossible for the people to know the merits of the candidates and to choose their representation wisely. With the executive's independence being paramount to the balance of the government, Oliver Ellsworth (CT) moves that special electors, chosen by state legislatures, select the executive. The motion is approved, though it is later revoked, and finally approved again on September 4.

July 26

The committee of the whole submits 23 resolutions based on the Virginia Plan to the committee of detail and adjourns until August 6.

August 6

The committee of detail distributes copies of the draft with a preamble and 23 resolutions to the convention. Debate resumes on key issues.

August 16

The question of which branch, legislative or executive, should have the power to declare war is debated, eventually deciding to give the right to the president, as the convention feels he will only do so when he knows the people will support it.

August 21

Slavery is debated, with the southern and the northern states unable to reach a compromise as to whether to continue to allow it. The issue is sent into committee, which returns with the recommendation that Congress be given the power to end the slave trade after 1800, and adds a fugitive slave clause to the Constitution.

August 31

After unanimously voting to prohibit religious tests for holding political office, the committee of the whole votes to make the ratification of nine of the thirteen states sufficient to put the Constitution into effect.

September 4–6

Debate continues on the powers of the president, with the delegates deciding on an executive office with a four-year term, eligible for reelection, and elected by specially chosen electors, who are picked by the states' legislatures.

September 10

The drafts are submitted to a committee of style to prepare a finished text. The committee is made up of William Samuel Johnson (CT), Gouverneur Morris (PA), Madison, Hamilton, and Rufus King (MA).

September 12

The committee of style submits its draft, consisting of a preamble and seven articles. There is a debate over whether to include a Bill of Rights, with the winning argument being that each state has a sufficient Bill of Rights in place already, and it is unanimously decided not to include one.

September 15

The final draft is printed.

September 17

After a speech written by Benjamin Franklin and read by James Wilson (PA), all of the delegates present [except for Eldridge Gerry (MA), Edmund Randolph (VA), and George Mason (VA)] sign the Constitution. Signers are:

President: *George Washington*

Connecticut: *William Samuel Johnson, Roger Sherman*

Delaware: *George Read, Gunning Bedford, Jr., John Dickinson, Richard Bassett, Jacob Broom*

Georgia: *William Few, Abraham Baldwin*

Maryland: *James McHenry, Daniel of St. Thomas Jenifer, Daniel Carroll*

Massachusetts: *Nathaniel Gorham, Rufus King*

New Hampshire: *John Langdon, Nicholas Gilman*

New Jersey: *William Livingston, David Brearley, William Paterson, Jonathon Dayton*

New York: *Alexander Hamilton*

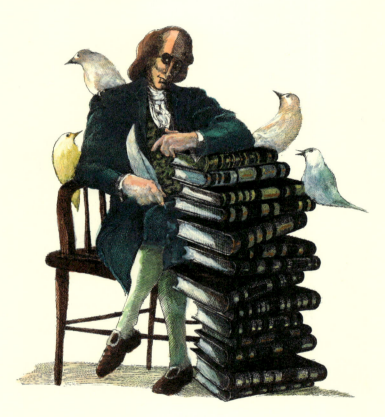

North Carolina: *William Blount, Richard Dobbs Spaight, Hugh Williamson*

Pennsylvania: *Benjamin Franklin, Thomas Mifflin, Robert Morris, George Clymer, Thomas FitzSimons, Jared Ingersoll, James Wilson, Gouverneur Morris*

South Carolina: *John Rutledge, Charles Cotesworth Pinckney, Charles Pinckney, Pierce Butler*

Virginia: *John Blair, James Madison, Jr.*

Secretary: *William Jackson*

After four months, the convention concludes.

September 19
The Constitution is published in the *Pennsylvania Packet* newspaper.

September 28
Congress approves the Constitution and sends it to the states to begin the process of ratification.

December 7
Delaware ratifies.

December 12
Pennsylvania ratifies.

December 18
New Jersey ratifies.

January 9, 1788
Connecticut ratifies.

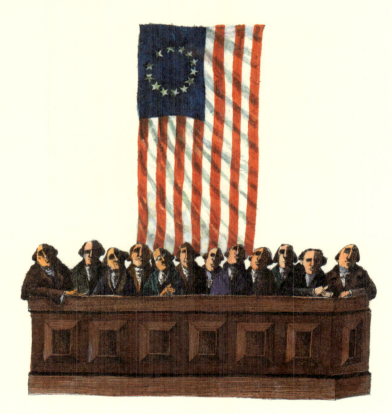

February 2
Georgia ratifies.

February 6
Massachusetts ratifies.

March 24
A Rhode Island referendum rejects the Constitution.

April 28
Maryland ratifies.

May 23
South Carolina ratifies.

June 21
New Hampshire ratifies. With nine states now signing off, the Constitution is officially ratified.

June 25
Virginia ratifies.

July 2
Congress is informed the Constitution has been ratified.

July 26
New York ratifies.

August 13
Congress votes to begin a new government on the following March 4.

March 4, 1789
The Constitution goes into effect.

September 25
The first ten amendments of the Constitution, known as the Bill of Rights, are proposed as a group. They protect individual liberties including: (I) freedom of speech, (II) the right to bear arms, (III) the right not to house military on your property, (IV) freedom from unreasonable searches and seizures of personal property, (V–VIII) the right to a fair and public trial with counsel and jury, and without excessive bail or fines inflicted, (IX) the right to not be denied freedoms by the articles in the Constitution and, (X) the rights not specified in the Constitution to be given to the states and the people of the states.

November 21
North Carolina ratifies.

May 29, 1790
Rhode Island ratifies.

February 7, 1795
The Eleventh Amendment is ratified, stating that the jurisdiction of the federal court cannot automatically hear cases brought against a state by the citizens of another state.

June 15, 1804
The Twelfth Amendment is ratified, further refining the process of electing the president and the vice president through the electoral college.

December 6, 1865
The Thirteenth Amendment is ratified, abolishing slavery.

July 9, 1868

The Fourteenth Amendment is ratified, attempting to ensure former slaves automatic United States citizenship, with all the rights and privileges of any other citizen.

February 3, 1870

The Fifteenth Amendment is ratified, granting all men, regardless of color, the right to vote.

February 3, 1913

The Sixteenth Amendment is ratified, granting the federal government an income tax which doesn't require a portion of the tax to go to the states.

April 8

The Seventeenth Amendment is ratified, requiring the representatives in the Senate to be elected by the people, and not by the state legislatures.

January 16, 1919

The Eighteenth Amendment is ratified, prohibiting the manufacture, sale, or transportation of alcohol.

August 18, 1920

The Nineteenth Amendment is ratified, giving women the right to vote.

January 23, 1933

The Twentieth Amendment is ratified, establishing a shorter time between the election of a president and the induction of a president.

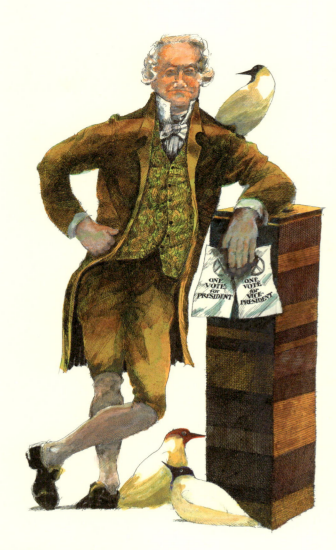

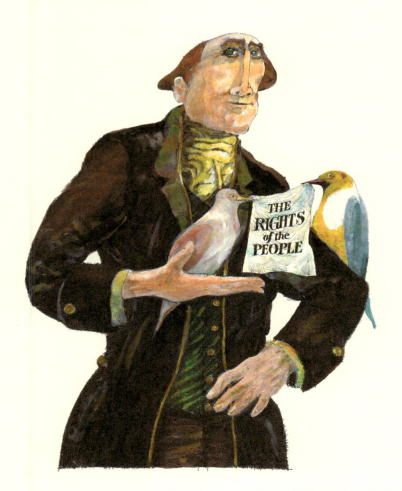

December 5

The Twenty-first Amendment is ratified, repealing the Eighteenth Amendment.

February 21, 1951

The Twenty-second Amendment is ratified, setting a two-term limit for the office of the president.

March 29, 1961

The Twenty-third Amendment is ratified, giving the residents of the District of Columbia electors, and thereby enabling them to vote in presidential elections.

January 23, 1964

The Twenty-fourth Amendment is ratified, barring poll taxes.

February 10, 1967

The Twenty-fifth Amendment is ratified, defining the order of succession in the case of presidential disability or death.

July 1, 1971

The Twenty-sixth Amendment is ratified, setting the legal voting age at 18.

May 7, 1992

The Twenty-seventh Amendment is ratified, barring Congressional pay increases from taking place until after the next election year.

GLOSSARY

Amendment

A provision of a constitution adopted after its original ratification. The U.S. Constitution has had only 27 amendments in over 200 years.

Appellate

Any court that can consider appeals and review the decisions of lower courts.

Apportionment

A determination of how many legislators should be sent to a legislative body from a given jurisdiction. The U.S. Constitution provides that each state is entitled to two senators and at least one representative.

Bill of attainder

A legislative act declaring an individual guilty of a crime without a trial and sentencing him or her to death; any legislatively instrumented punishment without a trial.

Bill of credit

A bill or promissory note issued by the government, upon its faith and credit, designed to circulate in the community as money.

Bill of Rights

The first 10 amendments to the U.S. Constitution, concerning basic individual liberties.

Cession

Giving up (of rights, property, etc) to another; surrendering.

Common law

The unwritten law of a country, based on custom, usage, and judicial decisions, as distinguished from statutory law. The common law tradition, based on precedent, is still the foundation of the American legal system, though much of what was originally common law has been converted into statutes over the years.

Compulsory

Compelled, required, involuntary.

Compulsory process

Forcing the attendance of witnesses who may not wish to testify in court.

Compulsion

Coercion; forcible inducement to the commission of an act.

Corruption of blood

Devolve to pass (on) to another, said of duty, rights, or authority.

Disparage

To lower in esteem; discredit; belittle.

Double jeopardy

The Fifth Amendment requirement, enforceable against the state through the Fourteenth Amendment, that no person "be subject for the same offense to be twice put in jeopardy of life or limb." This clause prevents retrials in either state or federal court of those already tried once— and thus placed in "jeopardy" once.

E pluribus unum

A Latin phrase meaning "one out of many;" the motto on the Great Seal of the United States.

Emolument

Gain from employment or position; salary or wage.

Enumerated powers

Those rights and responsibilities of the U.S. government specifically provided for and listed in the Constitution.

Ex post facto

Done or made after something, but having retroactive effect.

Ex post facto law

A law that makes something retroactively illegal—makes unlawful an act that was not a crime when committed. Laws are not considered *ex post facto* if they make the punishment less severe than it was when the crime was committed.

Excise Tax

A tax imposed on performance of an act, engaging in and occupation or enjoyment of a privilege; a tax on the manufacture, sale, or consumption of various commodities within a country, such as liquor or tobacco.

Impeachment
Bringing a public official before the proper tribunal on a charge of wrongdoing; the beginning of the process by which the President, Vice President, federal judges, and all civil officials of the U.S. may be removed from office if convicted of the charges brought against them; a written accusation.

Impost
A tax, especially a duty on imported goods; generic term for taxes.

Infringe
Encroach on (the rights of others).

Jurisdiction
A territory, subject matter, or person over which lawful authority may be exercised; the power of a court to act on a case.

Letter of marque
A document grantable, by the law of nations, whenever the subjects of one state are oppressed and injured by those of another, and justice is denied by that sate to which the oppressor belongs.

Naturalize
To confer citizenship upon (an alien).

Poll tax
A tax that is a prerequisite for voting, once widely used by southern states to discourage blacks from voting.

Preamble
A clause at the beginning of a constitution or statute explaining the reasons for its enactment and the objectives to be accomplished; the first paragraph of the U.S. Constitution, which begins "We the People…."

Pro tempore
For the time being; temporary.

Quorum
The minimum number of members required to be present at an assembly before it can validly proceed to transact business.

Ratify
To approve; to give formal sanction to; to authorize.

Redress
To make amends to; to remedy, as a fault; satisfaction for an injury or damages.

Repeal
The nullification of a law by the body that previously enacted it.

Reprisal
Injury done in return for injury received; retaliation, especially in war.

Republic
A state or nation in which the supreme power rests in all the citizens and is exercised by representatives elected by them.

Suffrage
The right to vote in political matters; franchise.

Tonnage
A duty or tax on ships, based on tons carried.

Transmit
To send or transfer from one person or place to another, or to communicate.

Treason
Betrayal of one's country to an enemy; the only crime defined by the Constitution.

Vested
Fixed, settled, absolute.

Welfare
Condition of health, happiness and prosperity, well-being; public financial or in-kind assistance available to citizens as a matter of right if they meet eligibility requirements, as a means test of income or assets below a preset minimum.

Writ
A formal legal document ordering or prohibiting some action. Writs include arrest warrants, search warrants, subpoenas, and summonses.

Writ of habeas corpus
A document directing a person detaining a prisoner to bring him or her before a judicial officer to determine the lawfulness of the imprisonment.

Bertolt Brecht said, "Every man needs help from every human born." So does every project, particularly big ambitious projects, of which this is one. My thanks go first and foremost to my amazing office, particularly to MAREN GREGERSON, whose work on the chronology was so superb, GREGORY WAKABAYASHI, whose grace enhanced the design immeasurably at every turn, and KATRINA FRIED, whose support was constant. To LINDA STORMES, the first "outside" fan, who brought me to BOB WIETRAK and SALLYE LEVENTHAL, whose instant response and good advice influenced many publishing decisions. To ALAN KAHN, whose friendship has been unstinting, and whose appreciation led the way to LEN RIGGIO, whose passion for the Constitution broadened my own. To SKIP DYE, who turned his enthusiasm into action immediately. To SYLVIA and EARL SHORRIS, who introduced me to The Library of America and SONDRA and MOREY MYERS, who simply took on the project as if it were their own. Amongst many other gifts, Sondra brought me to JERRY and ROSEMARIE SHESTACK, whose intelligence, humanity, and commitment to things that matter was yet another reassurance that we as a people can change anything for the good, if we put our hearts and minds to it.

And, is there a way for me to ever truly thank SAM FINK who has become my lifetime friend, who fertilizes the very ground upon which he walks—wherever that may be.

—*Lena Tabori*

A deluxe numbered edition limited to 1,500 copies of *The Constitution of the United States of America* is also available as 15" x 22" loose full-color folios in a cloth-covered clamshell portfolio with a reproduction of "The Constitution with Eagle" individually signed by the artist.

Published in 2006 by Welcome Books®
An imprint of Welcome Enterprises, Inc.
6 West 18th Street, New York, NY, 10011
(212) 989-3200; Fax (212) 989-3205
www.welcomebooks.com

Publisher: Lena Tabori
Editor: Katrina Fried
Editorial Assistant: Maren Gregerson
Designer: Gregory Wakabayashi

ISBN 10 : 0-941807-99-1
ISBN 13 : 978-0-941807-99-9

Library of Congress Cataloging-in-Publication Data

United States.
[Constitution]
The Constitution of the United States of America : with Benjamin Franklin's address
to the delegates upon the signing of the Constitution / illustrated and inscribed by Sam Fink.
p. cm.
ISBN 0-941807-99-1 (hardcover)
1. Constitutions--United States. I. Fink, Sam. II. Title.
KF4525 2006
342.7302'3--dc22
2006013894

First Edition
1 3 5 7 9 10 8 6 4 2

Printed in China through Palace Press International

The Constitution of the United States. We the People of the United States, in Order to form a more perfect Union, establish Justice, insure domestic Tranquility, provide for the common defence, promote the general Welfare, and secure the Blessings of Liberty to ourselves and our Posterity, do ordain and establish this Constitution for the United States of America.

ARTICLE I. Section 1. All legislative Powers herein granted shall be vested in a Congress of the United States, which shall consist of a Senate and House of Representatives. Section 2. The House of Representatives shall be composed of Members chosen every second Year by the People of the several States, and the Electors in each State shall have the Qualifications requisite for Electors of the most numerous Branch of the State Legislature. No Person shall be a Representative who shall not have attained to the Age of twenty five Years, and been seven Years a Citizen of the United States, and who shall not, when elected, be an Inhabitant of that State in which he shall be chosen. Representatives and direct Taxes shall be apportioned among the several States which may be included within this Union, according to their respective Numbers, which shall be determined by adding to the whole Number of free Persons, including those bound to Service for a Term of Years, and excluding Indians not taxed, three fifths of all other Persons. The actual Enumeration shall be made within three Years after the first Meeting of the Congress of the United States, and within every subsequent Term of ten Years, in such Manner as they shall by Law direct. The Number of Representatives shall not exceed one for every thirty Thousand, but each State shall have at Least one Representative; and until such enumeration shall be made, the State of New Hampshire shall be entitled to chuse three, Massachusetts eight, Rhode Island and Providence Plantations one, Connecticut five, New York six, New Jersey four, Pennsylvania eight, Delaware one, Maryland six, Virginia ten, North Carolina five, South Carolina five, and Georgia three. When vacancies happen in the Representation from any State, the Executive Authority thereof shall issue Writs of Election to fill such Vacancies. The House of Representatives shall chuse their Speaker and other Officers; and shall have the sole Power of Impeachment.

Section 3. The Senate of the United States shall be composed of two Senators from each State, chosen by the Legislature thereof, for six Years; and each Senator shall have one Vote. Immediately after they shall be assembled in Consequence of the first Election, they shall be divided as equally as may be into three Classes. The Seats of the Senators of the first Class shall be vacated at the Expiration of the second Year, of the second Class at the Expiration of the Fourth Year, and of the third Class at the Expiration of the sixth Year, so that one third may be chosen every second Year; and if Vacancies happen by Resignation, or otherwise, during the Recess of the Legislature of any State, the Executive thereof may make temporary Appointments until the next Meeting of the Legislature, which shall then fill such Vacancies. No Person shall be a Senator who shall not have attained to the Age of thirty Years, and been nine Years a Citizen of the United States, and who shall not, when elected, be an Inhabitant of that State for which he shall be chosen. The Vice President of the United States shall be President of the Senate, but shall have no Vote, unless they be equally divided. The Senate shall chuse their other Officers, and also a President pro tempore, in the absence of the Vice President, or when he shall exercise the Office of President of the United States. The Senate shall have the sole Power to try all Impeachments. When sitting for that Purpose, they shall be on Oath or Affirmation. When the President of the United States is tried, the Chief Justice shall preside: And no Person shall be convicted without the Concurrence of two thirds of the Members present. Judgment in Cases of Impeachment shall not extend further than to removal from Office, and disqualification to hold and enjoy any Office of honor, Trust or Profit under the United States: but the Party convicted shall nevertheless be liable and subject to Indictment, Trial, Judgment, and Punishment, according to Law. Section 4. The Times, Places and Manner of holding Elections for Senators and Representatives, shall be prescribed in each State by the Legislature thereof; but the Congress may at any time by Law make or alter such Regulations, except as to the Places of chusing Senators. The Congress shall assemble at least once in every Year, and such Meeting shall be on the first Monday in December, unless they shall by Law appoint a different Day. Section 5. Each House shall be the Judge of the Elections, Returns and Qualifications of its own Members, and a Majority of each shall constitute a Quorum to do Business; but a smaller Number may adjourn from day to day, and may be authorized to compel the Attendance of absent Members, in such Manner, and under such Penalties as each House may provide. Each House may determine the Rules of its Proceedings, punish its Members for disorderly behaviour, and, with the Concurrence of two thirds, expel a Member. Each House shall keep a Journal of its Proceedings, and from time to time publish the same, excepting such Parts as may in their Judgment require Secrecy; and the Yeas and Nays of the Members of either House on any question shall, at the Desire of one fifth of those Present, be entered on the Journal. Neither House, during the Session of Congress, shall, without the Consent of the other, adjourn for more than three days, nor to any other Place than that in which the two Houses shall be sitting. Section 6. The Senators and Representatives shall receive a Compensation for their Services, to be ascertained by Law, and paid out of the Treasury of the United States. They shall in all Cases, except Treason, Felony and Breach of the Peace, be privileged from Arrest during their Attendance at the Session of their respective Houses, and in going to and returning from the same; and for any Speech or Debate in either House, they shall not be questioned in any other Place. No Senator or Representative shall, during the Time for which he was elected, be appointed to any civil Office under the Authority of the United States, which shall have been created, or the Emoluments whereof shall have been encreased during such time; and no Person holding any Office under the United States, shall be a Member of either House during his Continuance in Office. Section 7. All Bills for raising Revenue shall originate in the House of Representatives; but the Senate may propose or concur with Amendments as on other Bills. Every Bill which shall have passed the House of Representatives and the Senate, shall, before it become a Law, be presented to the President of the United States; If he approve he shall sign it, but if not he shall return it, with his Objections to that House in which it shall have originated, who shall enter the Objections at large on their Journal, and proceed to reconsider it. If after such Reconsideration two thirds of that House shall agree to pass the Bill, it shall be sent, together with the Objections, to the other House, by which it shall likewise be reconsidered, and if approved by two thirds of that House, it shall become a Law. But in all such Cases the Votes of both Houses shall be determined by Yeas and Nays, and the Names of the Persons voting for and against the Bill shall be entered on the Journal of each House respectively. If any Bill shall not be returned by the President within ten Days (Sundays excepted) after it shall have been presented to him, the Same shall be a Law, in like Manner as if he had signed it, unless the Congress by their Adjournment prevent its Return, in which Case it shall not be a Law. Every Order, Resolution, or Vote to which the Concurrence of the Senate and House of Representatives may be necessary (except on a question of Adjournment) shall be presented to the President of the United States; and before the Same shall take Effect, shall be approved by him, or being disapproved by him, shall be repassed by two thirds of the Senate and House of Representatives, according to the Rules and Limitations prescribed in the Case of a Bill.

Section 8. The Congress shall have Power To lay and collect Taxes, Duties, Imposts and Excises, to pay the Debts and provide for the common Defence and general Welfare of the United States; but all Duties, Imposts and Excises shall be uniform throughout the United States; To borrow Money on the credit of the United States; To regulate Commerce with foreign Nations, and among the several States, and with the Indian Tribes; To establish an uniform Rule of Naturalization, and uniform Laws on the subject of Bankruptcies throughout the United States; To coin Money, regulate the Value thereof, and of foreign Coin, and fix the Standard of Weights and Measures; To provide for the Punishment of counterfeiting the Securities and current Coin of the United States; To establish Post Offices and post Roads; To promote the Progress of Science and useful Arts, by securing for limited Times to Authors and Inventors the exclusive Right to their respective Writings and Discoveries; To constitute Tribunals inferior to the supreme Court; To define and punish Piracies and Felonies committed on the high Seas, and Offenses against the Law of Nations; To declare War, grant Letters of Marque and Reprisal, and make Rules concerning Captures on Land and Water; To raise and support Armies, but no Appropriation of Money to that Use shall be for a longer Term than two Years; To provide and maintain a Navy; To make Rules for the Government and Regulation of the land and naval Forces; To provide for calling forth the Militia to execute the Laws of the Union, suppress Insurrections and repel Invasions; To provide for organizing, arming, and disciplining the Militia, and for governing such Part of them as may be employed in the Service of the United States, reserving to the States respectively, the Appointment of the Officers, and the Authority of training the Militia according to the discipline prescribed by Congress; To exercise exclusive Legislation in all Cases whatsoever, over such District (not exceeding ten Miles square) as may, by Cession of particular States, and the Acceptance of Congress, become the Seat of the Government of the United States, and to exercise like Authority over all Places purchased by the Consent of the Legislature of the State in which the Same shall be, for the Erection of Forts, Magazines, Arsenals, dock-Yards, and other needful Buildings; And To make all Laws which shall be necessary and proper for carrying into Execution the foregoing Powers, and all other Powers vested by this Constitution in the Government of the United States, or in any Department or Officer thereof. Section 9. The Migration or Importation of such Persons as any of the States now existing shall think proper to admit, shall not be prohibited by the Congress prior to the Year one thousand eight hundred and eight, but a Tax or duty may be imposed on such Importation, not exceeding ten dollars for each Person. The Privilege of the Writ of Habeas Corpus shall not be suspended, unless when in Cases of Rebellion or Invasion the public Safety may require it. No Bill of Attainder or ex post facto Law shall be passed. No Capitation, or other direct, Tax shall be laid, unless in Proportion to the Census or Enumeration herein before directed to be taken. No Tax or Duty shall be laid on Articles exported from any State. No Preference shall be given by any Regulation of Commerce or Revenue to the Ports of one State over those of another; nor shall Vessels bound to, or from, one State, be obliged to enter, clear, or pay Duties in another. No Money shall be drawn from the Treasury, but in Consequence of Appropriations made by Law; and a regular Statement and Account of the Receipts and Expenditures of all public Money shall be published from time to time. No Title of Nobility shall be granted by the United States: And no Person holding any Office of Profit or Trust under them, shall, without the Consent of the Congress, accept of any present, Emolument, Office, or Title, of any kind whatever, from any King, Prince, or foreign State. Section 10. No State shall enter into any Treaty, Alliance, or Confederation; grant Letters of Marque and Reprisal; coin Money; emit Bills of Credit; make any Thing but gold and silver Coin a Tender in Payment of Debts; pass any Bill of Attainder, ex post facto Law, or Law impairing the Obligation of Contracts, or grant any Title of Nobility. No State shall, without the Consent of the Congress, lay any Imposts or Duties on Imports or Exports, except what may be absolutely necessary for executing its inspection Laws: and the net Produce of all Duties and Imposts, laid by any State on Imports or Exports, shall be for the Use of the Treasury of the United States; and all such Laws shall be subject to the Revision and Controul of the Congress. No State shall, without the Consent of Congress, lay any Duty of Tonnage, keep Troops, or Ships of War in time of Peace, enter into any Agreement or Compact with another State, or with a foreign Power, or engage in War, unless actually invaded, or in such imminent Danger as will not admit of delay.

ARTICLE II. Section 1. The executive Power shall be vested in a President of the United States of America. He shall hold his Office during the Term of four Years, and, together with the Vice President, chosen for the same Term, be elected, as follows: Each State shall appoint, in such Manner as the Legislature thereof may direct, a Number of Electors, equal to the whole Number of Senators and Representatives to which the State may be entitled in the Congress: but no Senator or Representative, or Person holding an Office of Trust or Profit under the United States, shall be appointed an Elector. The Electors shall meet in their respective States, and vote by Ballot for two Persons, of whom one at least shall not be an Inhabitant of the same State with themselves. And they shall make a List of all the Persons voted for, and of the Number of Votes for each; which List they shall sign and certify, and transmit sealed to the Seat of the Government of the United States, directed to the President of the Senate. The President of the Senate shall, in the Presence of the Senate and House of Representatives, open all the Certificates, and the Votes shall then be counted. The Person having the greatest Number of Votes shall be the President, if such Number be a Majority of the whole Number of Electors appointed; and if there be more than one who have such Majority, and have an equal Number of Votes, then the House of Representatives shall immediately chuse by Ballot one of them for President; and if no Person have a Majority, then from the five highest on the List the said House shall in like Manner chuse the President. But in chusing the President, the Votes shall be taken by States, the Representation from each State having one Vote; a quorum for this Purpose shall consist of a Member or Members from two thirds of the States, and a Majority of all the States shall be necessary to a Choice. In every Case, after the Choice of the President, the Person having the greatest Number of Votes of the Electors shall be the Vice President. But if there should remain two or more who have equal Votes, the Senate shall chuse from them by Ballot the Vice President. The Congress may determine the Time of chusing the Electors, and the Day on which they shall give their Votes; which Day shall be the same throughout the United States. No Person except a natural born Citizen, or a Citizen of the United States, at the time of the Adoption of this Constitution, shall be eligible to the Office of President; neither shall any Person be eligible to that Office who shall not have attained to the Age of thirty five Years, and been fourteen Years a Resident within the United States. In Case of the Removal of the President from Office, or of his Death, Resignation, or Inability to discharge the Powers and Duties of the said Office, the Same shall devolve on the Vice President, and the Congress may by Law provide for the Case of Removal, Death, Resignation or Inability, both of the President and Vice President, declaring what Officer shall then act as President, and such Officer shall act accordingly, until the Disability be removed, or a President shall be elected. The President shall, at stated Times, receive for his Services, a Compensation, which shall neither be encreased nor diminished during the Period for which he shall have been elected, and he shall not receive within that Period any other Emolument from the United States, or any of them. Before he enter on the Execution of his Office, he shall take the following Oath or Affirmation:— "I do solemnly swear (or affirm) that I will faithfully execute the Office of President of the United States, and will to the best of my Ability, preserve, protect and defend the Constitution of the United States." Section 2. The President shall be Commander in Chief of the Army and Navy of the United States, and of the Militia of the several States, when called into the actual Service of the United States; he may require the Opinion, in writing, of the principal Officer in each of the executive Departments, upon any Subject relating to the Duties of their respective Offices, and he shall have Power to grant Reprieves and Pardons for Offenses against the United States, except in Cases of Impeachment. He shall have Power, by and with the Advice and Consent of the Senate, to make Treaties, provided two thirds of the Senators present concur; and he shall nominate, and by and with the Advice and Consent of the Senate, shall appoint Ambassadors, other public Ministers and Consuls, Judges of the supreme Court, and all other Officers of the United States, whose Appointments are not herein otherwise provided for, and which shall be established by Law: but the Congress may by Law vest the Appointment of such inferior Officers, as they think proper, in the President alone, in the Courts of Law, or in the Heads of Departments. The President shall have Power to fill up all Vacancies that may happen during the Recess of the Senate, by granting Commissions which shall expire at the End of their next Session. Section 3. He shall from time to time give to the Congress Information of the State of the Union, and recommend to their Consideration such Measures as he shall judge necessary and expedient; he may, on extraordinary Occasions, convene both Houses, or either of them, and in Case of Disagreement between them, with Respect to the Time of Adjournment, he may adjourn them to such Time as he shall think proper; he shall receive Ambassadors and other public Ministers; he shall take Care that the Laws be faithfully executed, and shall Commission all the Officers of the United States. Section 4. The President, Vice President and all civil Officers of the United States, shall be removed from Office on Impeachment for, and Conviction of, Treason, Bribery, or other high Crimes and Misdemeanors.

ARTICLE III. Section 1. The Judicial Power of the United States, shall be vested in one supreme Court, and in such inferior Courts as the Congress may from time to time ordain and establish. The Judges, both of the supreme and inferior Courts, shall hold their Offices during good Behaviour, and shall, at stated Times, receive for their Services, a Compensation, which shall not be diminished during their Continuance in Office. Section 2. The judicial Power shall extend to all Cases, in Law and Equity, arising under this Constitution, the Laws of the United States, and Treaties made, or which shall be made, under their Authority; to all Cases affecting Ambassadors, other public Ministers and Consuls; to all Cases of admiralty and maritime Jurisdiction; to Controversies to which the United States shall be a Party; to Controversies between two or more States; between a State and Citizens of another State; between Citizens of different States; between Citizens of the same State claiming Lands under Grants of different States, and between a State, or the Citizens thereof, and foreign States, Citizens or Subjects. In all Cases affecting Ambassadors, other public Ministers and Consuls, and those in which a State shall be Party, the supreme Court shall have original Jurisdiction. In all the other Cases before mentioned, the supreme Court shall have appellate Jurisdiction, both as to Law and Fact, with such Exceptions, and under such Regulations as the Congress shall make. The Trial of all Crimes, except in Cases of Impeachment, shall be by Jury; and such Trial shall be held in the State where the said Crimes shall have been committed; but when not committed within any State, the Trial shall be at such Place or Places as the Congress may by Law have directed. Section 3. Treason against the United States, shall consist only in levying War against them, or in adhering to their Enemies, giving them Aid and Comfort. No Person shall be convicted of Treason unless on the Testimony of two Witnesses to the same overt Act, or on Confession in open Court. The Congress shall have Power to declare the Punishment of Treason, but no Attainder of Treason shall work Corruption of Blood, or Forfeiture except during the Life of the Person attained.

ARTICLE IV. Section 1. Full Faith and Credit shall be given in each State to the public Acts, Records, and judicial Proceedings of every other State. And the Congress may by general Laws prescribe the Manner in which such Acts, Records and Proceedings shall be proved, and the Effect thereof. Section 2. The Citizens of each State shall be entitled to all Privileges and Immunities of Citizens in the several States. A Person charged in any State with Treason, Felony, or other Crime, who shall flee from Justice, and be found in another State, shall on Demand of the executive Authority of the State from which he fled, be delivered up, to be removed to the State having Jurisdiction of the Crime. No Person held to Service or Labour in one State, under the Laws thereof, escaping into another, shall, in Consequence of any Law or Regulation therein, be discharged from such Service or Labour, but shall be delivered up on Claim of the Party to whom such Service or Labour may be due. Section 3. New States may be admitted by the Congress into this Union; but no new State shall be formed or erected within the Jurisdiction of any other State; nor any State be formed by the Junction of two or more States, or Parts of States, without the Consent of the Legislatures of the States concerned as well as of the Congress. The Congress shall have Power to dispose of and make all needful Rules and Regulations respecting the Territory or other Property belonging to the United States; and nothing in this Constitution shall be so construed as to Prejudice any Claims of the United States, or of any particular State. Section 4. The United States shall guarantee to every State in this Union a Republican Form of Government, and shall protect each of them against Invasion; and on Application of the Legislature, or of the Executive (when the Legislature cannot be convened) against domestic Violence.

ARTICLE V. The Congress, whenever two thirds of both Houses shall deem it necessary, shall propose Amendments to this Constitution, or, on the Application of the Legislatures of two thirds of the several States, shall call a Convention for proposing Amendments, which, in either Case, shall be valid to all Intents and Purposes, as Part of this Constitution, when ratified by the Legislatures of three fourths of the several States, or by Conventions in three fourths thereof, as the one or the other Mode of Ratification may be proposed by the Congress; Provided that no Amendment which may be made prior to the Year One thousand eight hundred and eight shall in any Manner affect the first and fourth Clauses in the Ninth Section of the first Article; and that no State, without its Consent, shall be deprived of its equal Suffrage in the Senate.

ARTICLE VI. All Debts contracted and Engagements entered into, before the Adoption of this Constitution, shall be as valid against the United States under this Constitution, as under the Confederation. This Constitution, and the Laws of the United States which shall be made in Pursuance thereof; and all Treaties made, or which shall be made, under the Authority of the United States, shall be the supreme Law of the Land; and the Judges in every State shall be bound thereby, any Thing in the Constitution or Laws of any State to the Contrary notwithstanding. The Senators and Representatives before mentioned, and the Members of the several State Legislatures, and all executive and judicial Officers, both of the United States and of the several States, shall be bound by Oath or Affirmation, to support this Constitution; but no religious Test shall ever be required as a Qualification to any Office or public Trust under the United States.

ARTICLE VII. The Ratification of the Conventions of nine States, shall be sufficient for the Establishment of this Constitution between the States so ratifying the Same. Done in Convention by the Unanimous Consent of the States present the Seventeenth Day of September in the Year of our LORD one thousand seven hundred and Eighty seven and of the Independence of the United States of America the Twelfth. In Witness whereof We have hereunto subscribed our Names. George Washington, President and deputy from Virginia. New Hampshire: John Langdon, Nicholas Gilman. Massachusetts: Nathaniel Gorham, Rufus King. Connecticut: Wm. Saml. Johnson, Roger Sherman. New York: Alexander Hamilton. New Jersey: Wil. Livingston, David Brearley, Wm. Paterson, Jona. Dayton. Pennsylvania: B. Franklin, Thomas Mifflin, Robt. Morris, Geo. Clymer, Thos. FitzSimons, Jared Ingersoll, James Wilson, Gouv Morris. Delaware: Geo. Read, Gunning Bedford jun, John Dickinson, Richard Bassett, Jaco. Broom. Maryland: James McHenry, Dan of St Thos. Jenifer, Danl. Carroll. Virginia: John Blair, James Madison Jr. North Carolina: Wm. Blount, Richd. Dobbs Spaight, Hu. Williamson. South Carolina: J. Rutledge, Charles Cotesworth Pinckney, Charles Pinckney, Pierce Butler. Georgia: William Few, Abr Baldwin. In Convention Monday, September 17th, 1787. Present the States of New Hampshire, Massachusetts, Connecticut, Mr. Hamilton from New York, New Jersey, Pennsylvania, Delaware, Maryland, Virginia, North Carolina, South Carolina and Georgia. Resolved, That the preceding Constitution be laid before the United States in Congress assembled, and that it is the Opinion of this Convention, that it should afterwards be submitted to a Convention of Delegates, chosen in each State by the People thereof, under the Recommendation of its Legislature, for their Assent and Ratification; and that each Convention assenting to, and ratifying the Same, should give Notice thereof to the United States in Congress assembled. Resolved, That it is the Opinion of this Convention, that as soon as the Conventions of nine States shall have ratified this Constitution, the United States in Congress assembled should fix a Day on which Electors should be appointed by the States which shall have ratified the same, and a Day on which the Electors should assemble to vote for the President, and the Time and Place for commencing Proceedings under this Constitution. That after such Publication the Electors should be appointed, and the Senators and Representatives elected: That the Electors should meet on the Day fixed for the Election of the President, and should give their Votes on the Day fixed; that the Senators and Representatives should convene at the Time and Place assigned; that the Senators should appoint a President of the Senate, for the sole Purpose of receiving, opening and counting the Votes for President; and, that after he shall be chosen, the Congress, together with the President, should, without Delay, proceed to execute this Constitution.

ARTICLES IN ADDITION TO, AND AMENDMENT OF THE CONSTITUTION OF THE UNITED STATES OF AMERICA, PROPOSED BY CONGRESS AND RATIFIED BY THE LEGISLATURES OF THE SEVERAL STATES, PURSUANT TO THE FIFTH ARTICLE OF THE ORIGINAL CONSTITUTION. AMENDMENT I. Congress shall make no law respecting an establishment of religion, or prohibiting the free exercise thereof; or abridging the freedom of speech, or of the press; or the right of the people peaceably to assemble, and to petition the Government for a redress of grievances. AMENDMENT II. A well regulated Militia, being necessary to the security of a free State, the right of the people to keep and bear Arms, shall not be infringed. AMENDMENT III. No Soldier shall, in time of peace be quartered in any house, without the consent of the Owner, nor in time of war, but in a manner to be prescribed by law. AMENDMENT IV. The right of the people to be secure in their persons, houses, papers, and effects, against unreasonable searches and seizures, shall not be violated, and no Warrants shall issue, but upon probable cause, supported by Oath or affirmation, and particularly describing the place to be searched, and the persons or things to be seized. AMENDMENT V. No person shall be held to answer for a capital, or otherwise infamous crime, unless on a presentment or indictment of a Grand Jury, except in cases arising in the land or naval forces, or in the Militia, when in actual service in time of War or public danger; nor shall any person be subject for the same offence to be twice put in jeopardy of life or limb; nor shall be compelled in any criminal case to be a witness against himself, nor be deprived of life, liberty, or property, without due process of law; nor shall private property be taken for public use, without just compensation. AMENDMENT VI. In all criminal prosecutions, the accused shall enjoy the right to a speedy and public trial, by an impartial jury of the State and district wherein the crime shall have been committed, which district shall have been previously ascertained by law, and to be informed of the nature and cause of the accusation; to be confronted with the witnesses against him; to have compulsory process for obtaining witnesses in his favor, and to have the Assistance of Counsel for his defence. AMENDMENT VII. In suits at common law, where the value in controversy shall exceed twenty dollars, the right of trial by jury shall be preserved, and no fact tried by a jury, shall be otherwise re-examined in any Court of the United States, than according to the rules of the common law. AMENDMENT VIII. Excessive bail shall not be required, nor excessive fines imposed, nor cruel and unusual punishments inflicted. AMENDMENT IX. The enumeration in the Constitution, of certain rights, shall not be construed to deny or disparage others retained by the people. AMENDMENT X. The powers not delegated to the United States by the Constitution, nor prohibited by it to the States, are reserved to the States respectively, or to the people. AMENDMENT XI. The Judicial power of the United States shall not be construed to extend to any suit in law or equity, commenced or prosecuted against one of the United States by Citizens of another State, or by Citizens or Subjects of any Foreign State. AMENDMENT XII [1804]. The Electors shall meet in their respective states, and vote by ballot for President and Vice-President, one of whom, at least, shall not be an inhabitant of the same state with themselves; they shall name in their ballots the person voted for as President, and in distinct ballots the person voted for as Vice-President, and they shall make distinct lists of all persons voted for as President, and of all persons voted for as Vice-President, and of the number of votes for each, which lists they shall sign and certify, and transmit sealed to the seat of the government of the United States, directed to the President of the Senate; The President of the Senate shall, in the presence of the Senate and House of Representatives, open all the certificates and the votes shall then be counted; The person having the greatest number of votes for President, shall be the President, if such number be a majority of the whole number of Electors appointed; and if no person have such majority, then from the persons having the highest numbers not exceeding three on the list of those voted for as President, the House of Representatives shall choose immediately, by ballot, the President. But in choosing the President, the votes shall be taken by states, the representation from each state having one vote; a quorum for this purpose shall consist of a member or members from two-thirds of the states, and a majority of all the states shall be necessary to a choice. And if the House of Representatives shall not choose a President whenever the right of choice shall devolve upon them, before the fourth day of March next following, then the Vice-President shall act as President, as in the case of the death or other constitutional disability of the President. The person having the greatest number of votes as Vice-President, shall be the Vice-President, if such number be a majority of the whole number of Electors appointed, and if no person have a majority, then from the two highest numbers on the list, the Senate shall choose the Vice-President; a quorum for the purpose shall consist of two-thirds of the whole number of Senators, and a majority of the whole number shall be necessary to a choice. But no person constitutionally ineligible to the office of President shall be eligible to that of Vice-President of the United States. AMENDMENT XIII [1865]. Section 1. Neither slavery nor involuntary servitude, except as a punishment for crime whereof the party shall have been duly convicted, shall exist within the United States, or any place subject to their jurisdiction. Section 2. Congress shall have power to enforce this article by appropriate legislation. AMENDMENT XIV [1868]. Section 1. All persons born or naturalized in the United States, and subject to the jurisdiction thereof, are citizens of the United States and of the State wherein they reside. No State shall make or enforce any law which shall abridge the privileges or immunities of citizens of the United States; nor shall any State deprive any person of life, liberty, or property, without due process of law; nor deny to any person within its jurisdiction the equal protection of the laws. Section 2. Representatives shall be apportioned among the several States according to their respective numbers, counting the whole number of persons in each State, excluding Indians not taxed. But when the right to vote at any election for the choice of electors for President and Vice-President of the United States, Representatives in Congress, the Executive and Judicial officers of a State, or the members of the Legislature thereof, is denied to any of the male inhabitants of such State, being twenty-one years of age, and citizens of the United States, or in any way abridged, except for participation in rebellion, or other crime, the basis of representation therein shall be reduced in the proportion which the number of such male citizens shall bear to the whole number of male citizens twenty-one years of age in such State. Section 3. No person shall be a Senator or Representative in Congress, or elector of President and Vice-President, or hold any office, civil or military, under the United States, or under any State, who, having previously taken an oath, as a member of Congress, or as an officer of the United States, or as a member of any State legislature, or as an executive or judicial officer of any State, to support the Constitution of the United States, shall have engaged in insurrection or rebellion against the same, or given aid or comfort to the enemies thereof. But Congress may by a vote of two-thirds of each House, remove such disability. Section 4. The validity of the public debt of the United States, authorized by law, including debts incurred for payment of pensions and bounties for services in suppressing insurrection or rebellion, shall not be questioned. But neither the United States nor any State shall assume or pay any debt or obligation incurred in aid of insurrection or rebellion against the United States, or any claim for the loss or emancipation of any slave; but all such debts, obligations and claims shall be held illegal and void. Section 5. The Congress shall have power to enforce, by appropriate legislation, the provisions of this article. AMENDMENT XV [1870]. Section 1. The right of citizens of the United States to vote shall not be denied or abridged by the United States or by any State on account of race, color, or previous condition of servitude. Section 2. The Congress shall have power to enforce this article by appropriate legislation. AMENDMENT XVI [1913]. The Congress shall have power to lay and collect taxes on incomes, from whatever source derived, without apportionment among the several States, and without regard to any census or enumeration. AMENDMENT XVII [1913]. The Senate of the United States shall be composed of two Senators from each State, elected by the people thereof, for six years; and each Senator shall have one vote. The electors in each State shall have the qualifications requisite for electors of the most numerous branch of the State legislatures. When vacancies happen in the representation of any State in the Senate, the executive authority of such State shall issue writs of election to fill such vacancies: Provided, That the legislature of any State may empower the executive thereof to make temporary appointments until the people fill the vacancies by election as the legislature may direct. This amendment shall not be so construed as to affect the election or term of any Senator chosen before it becomes valid as part of the Constitution. AMENDMENT XVIII [1919]. Section 1. After one year from the ratification of this article the manufacture, sale, or transportation of intoxicating liquors within, the importation thereof into, or the exportation thereof from the United States and all territory subject to the jurisdiction thereof for beverage purposes is hereby prohibited. Section 2. The Congress and the several States shall have concurrent power to enforce this article by appropriate legislation. Section 3. This article shall be inoperative unless it shall have been ratified as an amendment to the Constitution by the legislatures of the several States, as provided in the Constitution, within seven years from the date of the submission hereof to the States by the Congress. AMENDMENT XIX [1920]. The right of citizens of the United States to vote shall not be denied or abridged by the United States or by any State on account of sex. Congress shall have power to enforce this article by appropriate legislation. AMENDMENT XX [1933]. Section 1. The terms of the President and Vice President shall end at noon on the 20th day of January, and the terms of Senators and Representatives at noon on the 3d day of January, of the years in which such terms would have ended if this article had not been ratified; and the terms of their successors shall then begin. Section 2. The Congress shall assemble at least once in every year, and such meeting shall begin at noon on the 3d day of January, unless they shall by law appoint a different day. Section 3. If, at the time fixed for the beginning of the term of the President, the President elect shall have died, the Vice President elect shall become President. If a President shall not have been chosen before the time fixed for the beginning of his term, or if the President elect shall have failed to qualify, then the Vice President elect shall act as President until a President shall have qualified; and the Congress may by law provide for the case wherein neither a President elect nor a Vice President elect shall have qualified, declaring who shall then act as President, or the manner in which one who is to act shall be selected, and such person shall act accordingly until a President or Vice President shall have qualified. Section 4. The Congress may by law provide for the case of the death of any of the persons from whom the House of Representatives may choose a President whenever the right of choice shall have devolved upon them, and for the case of the death of any of the persons from whom the Senate may choose a Vice President whenever the right of choice shall have devolved upon them. Section 5. Sections 1 and 2 shall take effect on the 15th day of October following the ratification of this article. Section 6. This article shall be inoperative unless it shall have been ratified as an amendment to the Constitution by the legislatures of three-fourths of the several States within seven years from the date of its submission. AMENDMENT XXI [1933]. Section 1. The eighteenth article of amendment to the Constitution of the United States is hereby repealed. Section 2. The transportation or importation into any State, Territory, or possession of the United States for delivery or use therein of intoxicating liquors, in violation of the laws thereof, is hereby prohibited. Section 3. This article shall be inoperative unless it shall have been ratified as an amendment to the Constitution by conventions in the several States, as provided in the Constitution, within seven years from the date of the submission hereof to the States by the Congress. AMENDMENT XXII [1951]. Section 1. No person shall be elected to the office of the President more than twice, and no person who has held the office of President, or acted as President, for more than two years of a term to which some other person was elected President shall be elected to the office of the President more than once. But this Article shall not apply to any person holding the office of President when this Article was proposed by the Congress, and shall not prevent any person who may be holding the office of President, or acting as President, during the term within which this Article becomes operative from holding the office of President or acting as President during the remainder of such term. Section 2. This article shall be inoperative unless it shall have been ratified as an amendment to the Constitution by the legislatures of three-fourths of the several States within seven years from the date of its submission to the States by the Congress. AMENDMENT XXIII [1961]. Section 1. The District constituting the seat of Government of the United States shall appoint in such manner as the Congress may direct: A number of electors of President and Vice President equal to the whole number of Senators and Representatives in Congress to which the District would be entitled if it were a State, but in no event more than the least populous State; they shall be in addition to those appointed by the States, but they shall be considered, for the purposes of the election of President and Vice President, to be electors appointed by a State; and they shall meet in the District and perform such duties as provided by the twelfth article of amendment. Section 2. The Congress shall have power to enforce this article by appropriate legislation. AMENDMENT XXIV [1964]. Section 1. The right of citizens of the United States to vote in any primary or other election for President or Vice President, for electors for President or Vice President, or for Senator or Representative in Congress, shall not be denied or abridged by the United States or any State by reason of failure to pay any poll tax or other tax. Section 2. The Congress shall have power to enforce this article by appropriate legislation. AMENDMENT XXV [1967]. Section 1. In case of the removal of the President from office or of his death or resignation, the Vice President shall become President. Section 2. Whenever there is a vacancy in the office of the Vice President, the President shall nominate a Vice President who shall take office upon confirmation by a majority vote of both Houses of Congress. Section 3. Whenever the President transmits to the President pro tempore of the Senate and the Speaker of the House of Representatives his written declaration that he is unable to discharge the powers and duties of his office, and until he transmits to them a written declaration to the contrary, such powers and duties shall be discharged by the Vice President as Acting President. Section 4. Whenever the Vice President and a majority of either the principal officers of the executive departments or of such other body as Congress may by law provide, transmit to the President pro tempore of the Senate and the Speaker of the House of Representatives their written declaration that the President is unable to discharge the powers and duties of his office, the Vice President shall immediately assume the powers and duties of the office as Acting President. Thereafter, when the President transmits to the President pro tempore of the Senate and the Speaker of the House of Representatives his written declaration that no inability exists, he shall resume the powers and duties of his office unless the Vice President and a majority of either the principal officers of the executive department or of such other body as Congress may by law provide, transmit within four days to the President pro tempore of the Senate and the Speaker of the House of Representatives their written declaration that the President is unable to discharge the powers and duties of his office. Thereupon Congress shall decide the issue, assembling within forty-eight hours for that purpose if not in session. If the Congress, within twenty-one days after receipt of the latter written declaration, or, if Congress is not in session, within twenty-one days after Congress is required to assemble, determines by two-thirds vote of both Houses that the President is unable to discharge the powers and duties of his office, the Vice President shall continue to discharge the same as Acting President; otherwise, the President shall resume the powers and duties of his office. AMENDMENT XXVI [1971]. Section 1. The right of citizens of the United States, who are 18 years of age or older, to vote shall not be denied or abridged by the United States or by any State on account of age. Section 2. The Congress shall have power to enforce this article by appropriate legislation.